-DIY-
HENNA TATTOOS

Learn Decorative Patterns, Draw Modern Designs and Create Everyday Body Art

Aroosa Shahid

Ulysses Press

Published in the US by
Ulysses Press
P.O. Box 3440
Berkeley, CA 94703
www.ulyssespress.com

ISBN: 978-1-61243-800-9
Library of Congress Control Number 2018930695

Printed in the United States by Versa Press
10 9 8 7 6 5 4 3 2 1

Acquisitions editor: Casie Vogel
Managing editor: Claire Chun
Project editor: Claire Sielaff
Editor: Lauren Harrison
Proofreader: Shayna Keyles
Design and layout: Malea Clark-Nicholson
Production: Jake Flaherty
Interior art: background design © Nadezhda Molkentin/shutterstock.com

Distributed by Publishers Group West

Dedicated to my family,
followers, and supporters.

TABLE OF CONTENTS

SECTION I: Basics

SECTION II: Henna Tattoos

SECTION I

BASICS

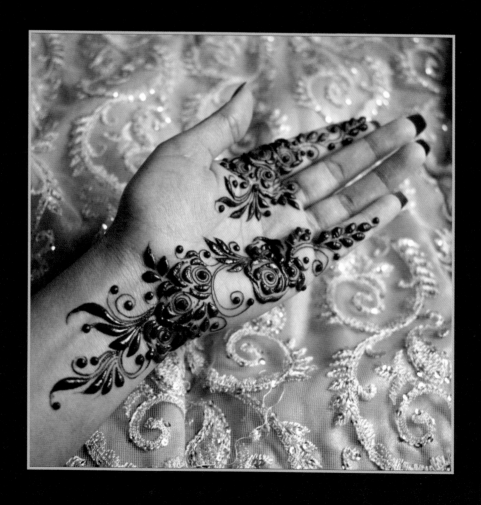

INTRODUCTION

Natural henna is an elegant and safe method of body adornment practiced as part of different cultures and traditions around the world. Henna application is easy and painless, resulting in a temporary stain on the skin.

What Is Henna?

Henna, also known as *mehendi*, comes from the henna plant, called *Lawsonia inermis*. The leaves from the plant are dried, milled, and sifted to form a fine powder. The powder is then turned into a smooth paste by combining it with a liquid, such as water or lemon juice, and various essential oils, like cajeput, eucalyptus, lavender, and tea tree. This process allows the dye contained within the leaves, called lawsone, to be released.

Many different methods can be used to apply the paste to the skin; however, the most common and effective method is by using a plastic cone, similar to a piping bag used for decorating pastries. When the paste is applied to the skin, the dye will begin to stain the skin and the paste will dry on the skin after 30 minutes. The longer the paste is kept on the skin, the darker the stain will be. Natural henna paste leaves a bright orange stain when initially removed, and it darkens over the course of the day. Henna naturally leaves the deepest and longest-lasting stains on the palms of the hand and soles of the feet due to the thickness of the skin in those areas. The stain will remain on the skin for four to five days, after which it will slowly fade away through the natural exfoliation of the skin. Henna that immediately stains the skin a deep color is unnatural, may contain chemicals, and should be avoided.

History of Henna Art

Henna art is a centuries-old tradition practiced in the Middle East and Asian countries. Henna was traditionally used for various purposes. Due to its cooling properties, people living in hot climates would use henna as a way of cooling their body from the heat. This is why their whole hands and feet would be covered in a block of orange stain. Evidence suggests ancient Egyptians also used henna to dye the nails and hair of mummies before they were buried. In addition to this, henna was used as a form of decorating the body with different patterns. In Asian countries such as India and Pakistan, it is custom for brides' hands to be adorned by henna, often in the shape of a filled circle in the middle of the hand, which gradually developed into the intricate and precise mandala designs seen today. It is believed that a dark stain on a bride's hands means she will have a prosperous married life.

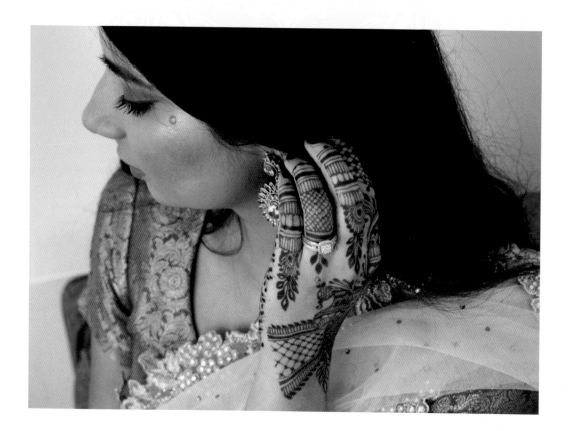

How I Got Started with Henna

My interest in henna first sparked when, as a child, my cousins would apply henna on my hands for the Islamic festival of Eid. I was intrigued by the detailed designs they so effortlessly made. This made me want to try applying henna too. I began doing henna on family as my hobby while I was still in high school. As I got better with time and practice, I took on a few clients that were drawn to my work through mutual friends. In the next few years, I established my work online through social networking sites, and my Instagram quickly gained popularity. During this time I experimented with henna art using acrylic paint and started designing candles, phone cases, and canvases. Phone cases became my most sought-after products.

Many henna artists that I met online have been an inspiration to me and have helped me come a long way in my passion for henna. I have learned so much about using and making natural henna from the online henna community, which would not have been possible otherwise. I believe anyone can become a henna artist as long as they take time to practice and improve their work continuously. Being a henna artist means challenging yourself and your art daily. Even when you think you have reached a point where you are very good at your work, there is always room for improvement. I feel blessed to be able to follow my passion for henna and the endless opportunities it has brought me.

SUPPLIES AND TOOLS

In this chapter, you will learn about the supplies and tools needed to make your own henna cones. You will also become familiar with the different types of henna powders used to make henna paste, and instructions on how to best store henna cones so they last longer. Finally, you will learn all the tips and tricks to achieve the darkest henna stains.

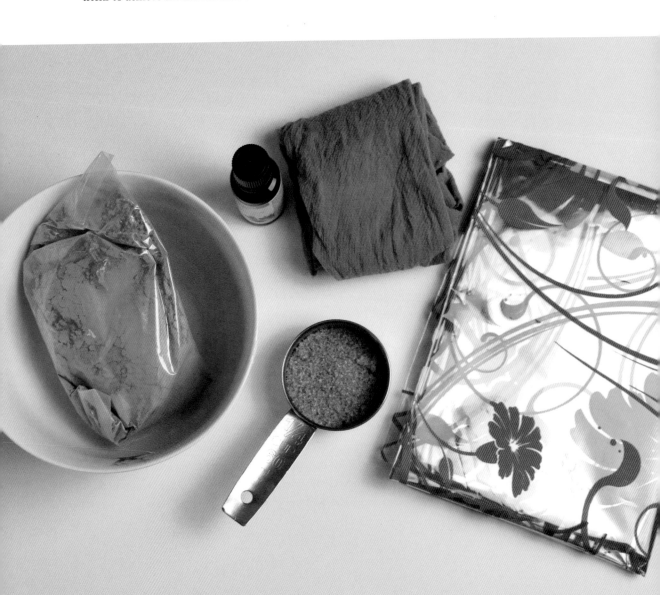

HOW TO MAKE HENNA PASTE

Making your own natural henna paste at home is very easy and requires only a few ingredients. Unlike store-bought henna cones, homemade henna cones are safe to use on the skin as you are aware of everything that has gone into making them. The most important thing is to ensure you are using good-quality henna powder.

Henna powder comes in many forms and varieties. Some result in a creamy paste and others provide a stringier paste. The most popular are Sojat and Rajasthani henna powders. Look for the triple-sifted or five-times-sifted henna powders, as these will make it easy to mix and you'll get a smoother paste.

You will also need an essential oil, such as eucalyptus or cajeput. Lavender essential oil can be used for sensitive skin. Henna paste can be mixed with water or lemon juice. It is believed that using freshly squeezed lemon juice to mix the paste may provide darker stains. However, mixing paste with water will also provide fairly dark stains. Generally, henna stains are darkest on the palms and soles of the feet, as the skin is thicker on those areas and the dye can penetrate deeper. On the top of the hands, the stains tend to be less dark due to the thinness of the skin.

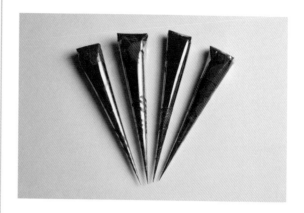

YIELD: 4 to 5 medium cones · TIME: 12 to 24 hours

Supplies

- ¼ cup (25 g) body-art-quality henna powder
- 2 teaspoons essential oil
- 2 teaspoons sugar
- Water or lemon juice

Equipment

- Bowl
- Spatula
- Plastic wrap
- Nylon stockings
- Carrot bags
- Pre-rolled empty cellophane cones

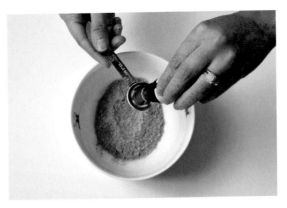

1. Add henna powder, sugar, and essential oil to a bowl.

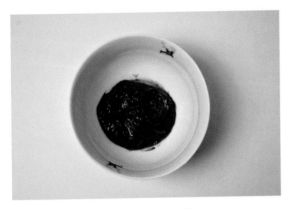

2. Mix the paste with the spatula, adding water or lemon juice gradually until you get a lumpy, tooth-paste-like consistency. Keep mixing so that most of the lumps disappear. Don't worry if some lumps remain, as these will dissolve during dye release.

3. Cover the paste with plastic wrap and let it sit at room temperature for 12 to 24 hours while the dye release takes place. This may take the full 24 hours if you are using lemon juice.

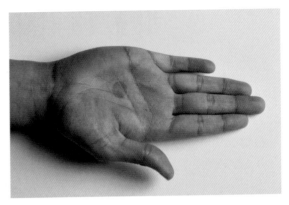

4. You will know dye has released if the top layer of the paste is darker than the lower layers. Another way to check is to do a 5-minute paste test on the palm: Leave some paste on the hand for 5 minutes. You should be left with a bright orange stain on the skin, indicating the paste is ready to use.

5. Now it's time to adjust the consistency. The paste will be quite thick at this point, so add in a little water (or lemon juice) and mix until it becomes a smooth and silky consistency. How thick or thin the henna paste will be depends on personal preference. With more practice, you will be able to identify how thick or thin you prefer.

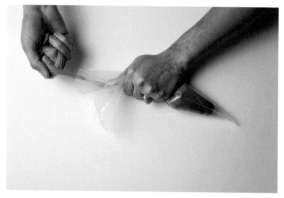

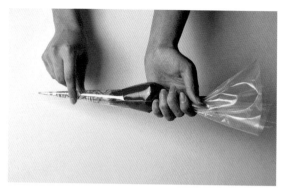

7. Cut the tip of the carrot bag and place it in the empty cellophane cone (see page 14 for how to make a cellophane cone). Squeeze some henna paste into the cone.

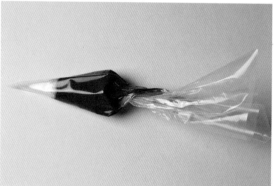

6. The next step is to strain the henna paste. This is the process of pulling the paste through a thin, mesh-like material to get rid of all remaining lumps and get the smoothest paste. Put the henna paste in a nylon stocking and put the stocking in a carrot bag. Twist and hold the bag with one hand and pull the stocking out of the carrot bag with the other hand. Once the entire stocking has been pulled out of the bag, you should be left with smooth henna paste ready to be put in to cones.

8. Fold the end of the cone and use scotch tape to close it securely. Repeat with remaining cones.

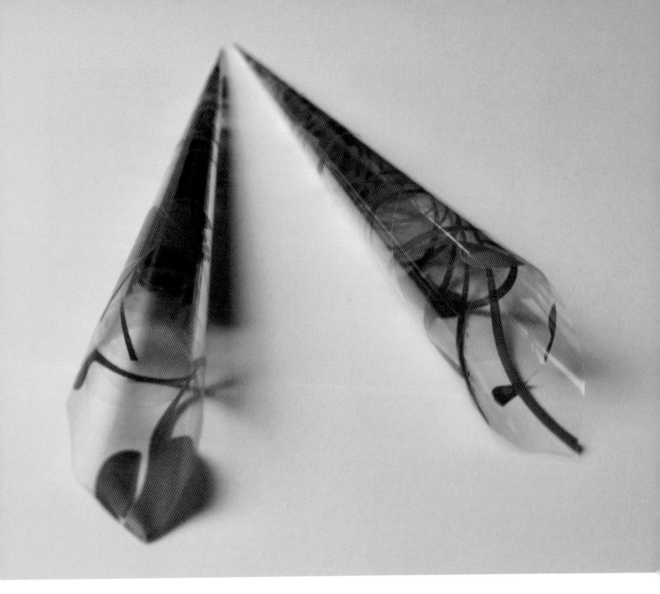

HOW TO ROLL A CELLOPHANE CONE

Buy some good-quality cellophane paper —it should not be too thin and flimsy, nor too thick.

Supplies

Cellophane paper · Scissors · Scotch tape

1. Cut out a rectangular piece of cellophane. The size of the rectangle will depend on how big the cone needs to be. If you are making more than one cone, then cut out several pieces of same size cellophane sheets.

2. Take one corner of the paper and start rolling inward while holding the other end, which will be the tip of the cone.

3. While rolling slowly, you can adjust the opening of the tip of the cone to be as wide or narrow you want. It's always best to keep it narrow, as you can cut more of the tip later to widen it if needed.

4. Continue rolling the cellophane into a cone until you have no paper left to roll. Keep a firm hold of the tip to prevent it from getting any wider or loosening.

5. Once you have rolled the whole sheet, hold it and tape the end securely.

6. Now the cones are ready to be filled with henna paste or acrylic paint.

AFTERCARE AND ACHIEVING DARK HENNA STAINS

Once you have created the henna design on the skin, what you do after is very important in determining how dark your henna stain will be. Here you will learn the best ways to ensure you get the most stunning henna stain.

1. Depending on the design, your henna should dry within 20 to 30 minutes after application. Be careful not to smudge anything while it is drying. You can use a hair dryer to speed up the drying process.

2. The most obvious and important tip is to keep the henna paste on the skin for as long as possible, at least five hours, or overnight for the darkest stain. The sugar that you added when making the henna paste helps it stick on the skin longer. However, you can also make a sealant using a lemon and sugar mixture and dab this on the dry henna design to help it say on the skin. To create the sealant, combine the juice from half a lemon and add 1 tablespoon sugar. Mix until the sugar dissolves and a sticky solution is created.

3. Try to keep your hands and body warm, as the heat will aid in achieving a dark stain.

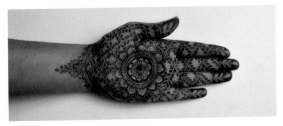

4. Remove the henna paste by rubbing it off the skin; it should crumble off. Do not wash it off with water, as this will affect the staining process. If there are some stubborn bits, then dab some coconut oil on the hand, let it sit, then use a butter knife to scrape the remaining paste off.

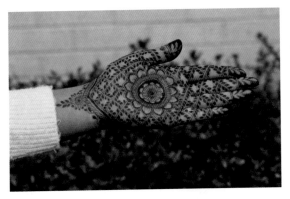

5. The henna stain should be bright orange immediately after removal. Try to avoid water for the next 12 hours and keep hands moisturized with lotion or other moisturizers.

6. In the next 24 hours, the stain will reach its peak and develop into a dark brown color. The stain shown on the opposite page is a very dark, almost black color because it is on the palm of the hand.

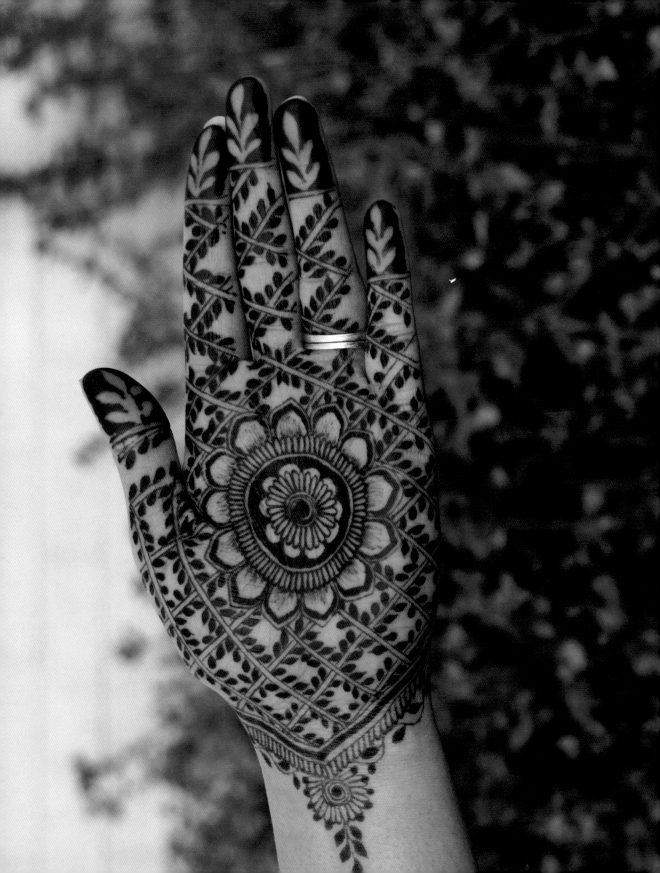

CHAPTER 3

BASIC ELEMENTS AND TECHNIQUES

Different types of flowers, leaves, paisleys, and other techniques used commonly in henna will be shown in this chapter, as well as tips on how to build your own designs and patterns. Mastering these basic elements is key.

Simple Flower: This is the most common flower used in almost all designs. As you become more advanced, the simple flower may take on its own personality..

Large Flower: Large, detailed flowers are created by using the simple flower as the base.

Roses: Roses are commonly found in Arabic-style henna patterns, which look great when combined with Indian-style henna patterns. To make thicker strokes of petals, apply pressure on the henna cone and release.

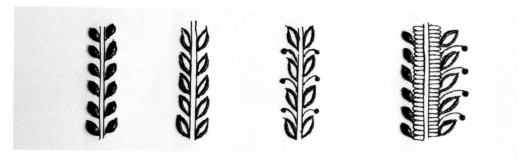

Leaves: Leaves are an important element in henna designs, as they can be used anywhere to create further detail. Leaves can be filled or unfilled, and are created by applying pressure on the henna cone and releasing. Learn how to make additional swirls for your leaf patterns on page 25.

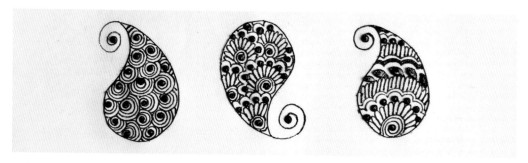

Paisleys: Paisleys have been used in henna deigns the longest because of their unique shape, which allows for different intricate fills to be added inside them.

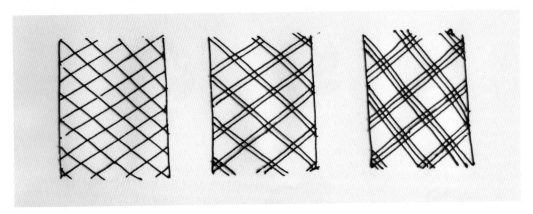

Netting: Another great way to fill in a band of empty space and create more detail is by using netting. You can create this effect by drawing lines crossing over each other to create a pattern that resembles a net or grid.

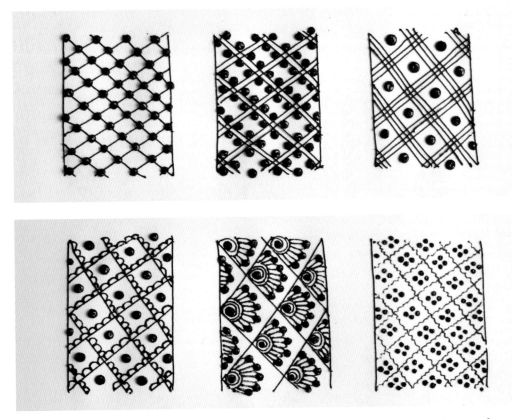

You can also add your own flair to netting fills by adding double lines, dots in different places, and flowers or leaves in the empty spaces in between.

TATTOOS

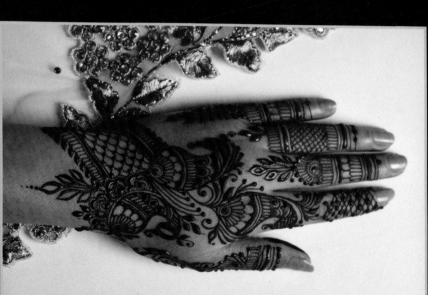

SIMPLE AND EASY HENNA DESIGNS

Now that you've practiced the basics, it's time to start creating some designs. In this chapter you'll find a variety of fairly simple patterns that incorporate the basic elements and techniques you've just learned.

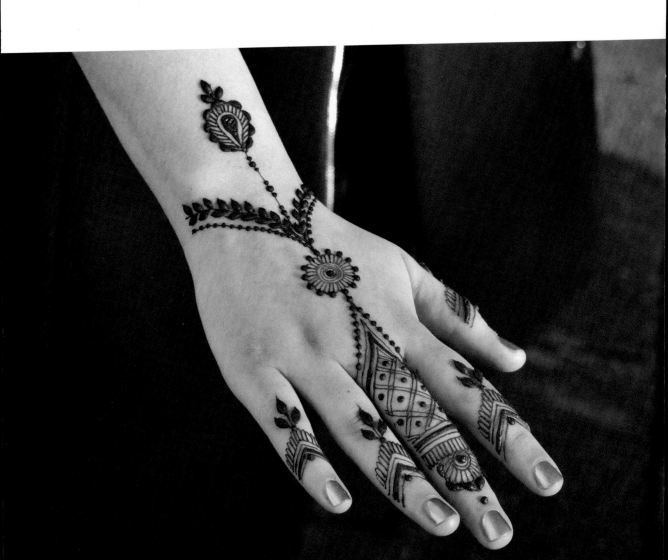

SIMPLE HENNA DESIGN

This simple henna design is inspired by jewelry and looks great on the hand. It is quick and easy to create, especially for beginners, using a few basic elements and techniques.

1. Draw a simple flower with thin petals on the middle of the hand. Now draw two lines from each side of the wrist meeting up to the flower.

2. Create a vine of leaves underneath each line. Have these also connect to the flower.

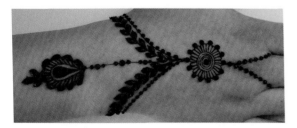

3. From the place where the vines meet, draw a dotted line going up the arm. At the end of this line, create a teardrop shape with thin and bold petals around it. Then draw two dotted lines in a V shape, extending from the side of the middle finger and meeting at top of the flower.

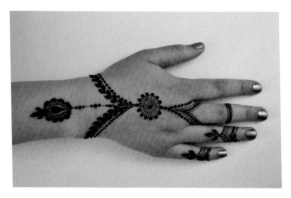

4. Create thick and thin lines around the V shape on the middle finger. At the center of the middle finger, draw another thick line surrounded by two thin lines.

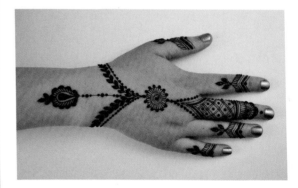

5. Fill the empty space on the middle finger with lines crossing each other to create a netting effect. Put a dot in each of the squares in the net, finishing the finger design with a simple flower on top. Decorate the rest of the fingers with a simple V shape near the top knuckle. Add a dot within the V, and at the bottom point of the V, add three filled leaves pointing down toward the hand.

SIMPLE SWIRLY DESIGN

A simple flowy design with lots of swirls, roses, and leafy lines,
this design has a stripe-like layout but is quick to create.

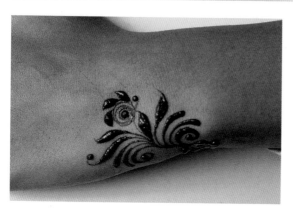

1. Begin at the outside edge of the hand at the wrist. Draw a swirl and layer leafy lines around it, then draw another swirl at the other side of the first swirl. Repeat the same leafy lines around it. Now draw a rose within these two swirly elements.

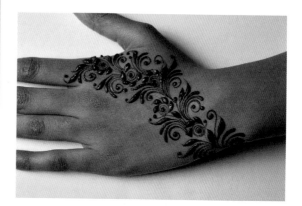

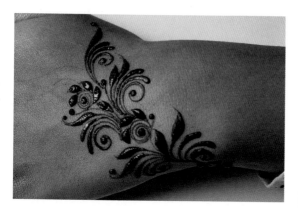

2. Repeat the same pattern with two swirly elements and a rose between them. Extend the pattern diagonally toward the index finger.

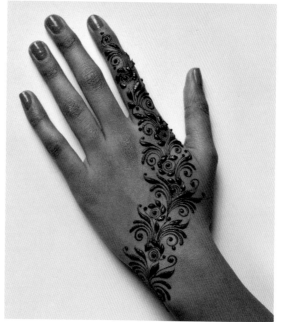

3. Continue the pattern onto the index finger until you reach the tip. This design does not include any design on the other fingers, as the main focus is the swirly design on the hand.

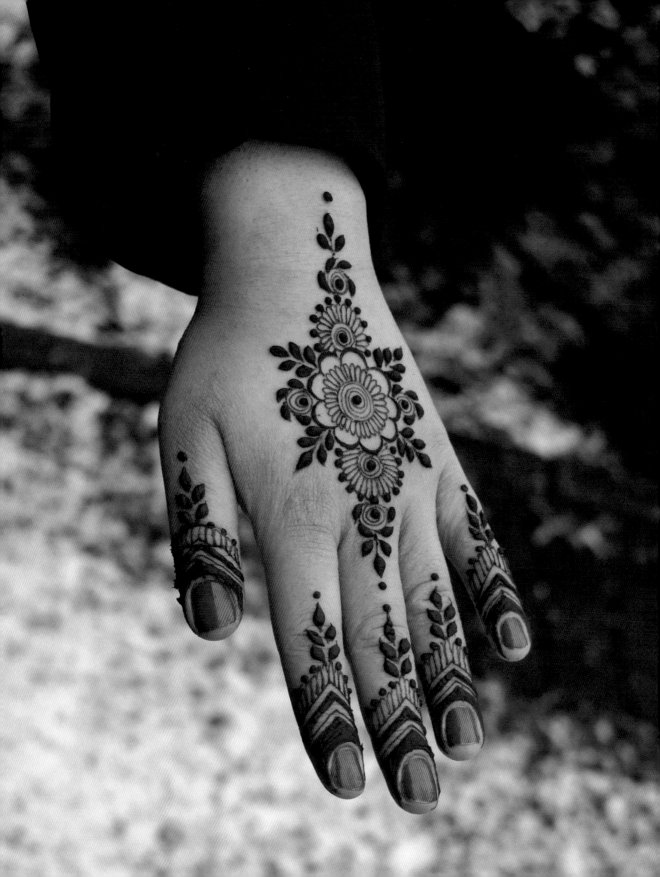

DELICATE FLORAL HENNA DESIGN

This delicate henna design is quick and easy to do. It creates a beautiful minimal look on the hand, and is ideal for those who don't want more extensive henna designs.

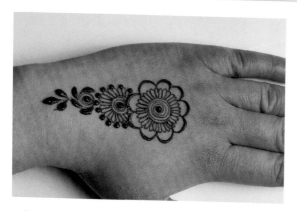

1. Create a simple flower in the center of the hand and layer large leaves around it. Create another simple flower below that but with dots around it. Make a final small rose underneath, so that the flowers go from biggest to smallest.

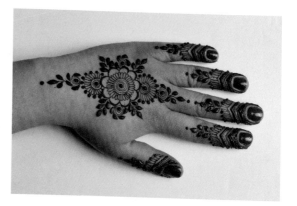

3. Draw V-shaped lines on the tops of the fingers and also outline the nails using thick lines. Create thin petals underneath the V shapes. Draw some vines of leaves under the points of the V shapes, toward the wrist, to match the leaves on the hand.

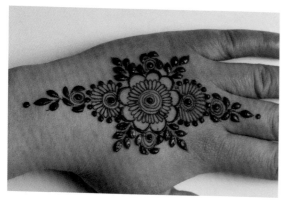

2. Make another simple flower and rose on top of the main flower, extending toward the top of the hand. Add a rose at each side of the main flower, and fill in the space beside the roses with leafy vines.

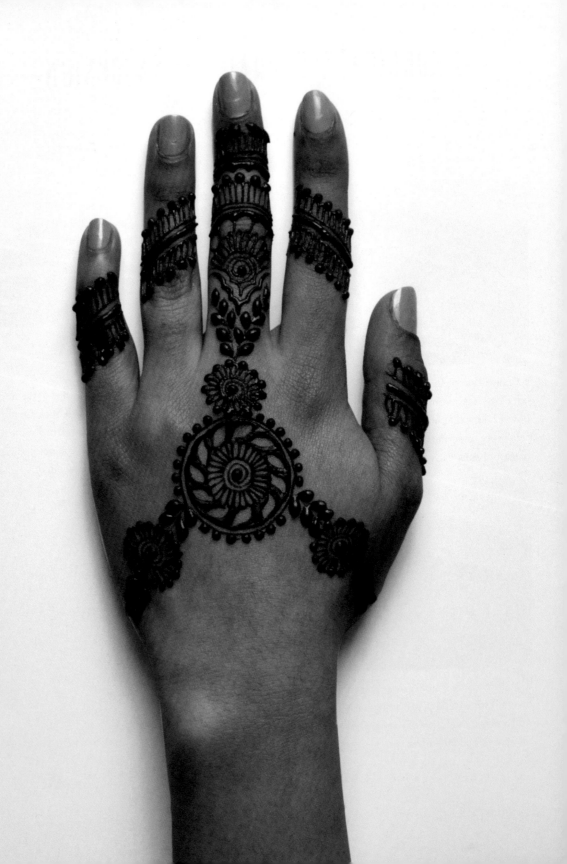

EASY JEWELRY-INSPIRED DESIGN

This simple design is inspired by hand jewelry. The focus is one main flower in the middle of the hand and two smaller flowers placed in a structured layout joined by leafy vines. Jewelry-inspired designs are very popular and look beautiful on the hands.

1. Draw a simple small flower in the middle of the hand. Next, create an outline of leaves around the flower. Leave them unfilled.

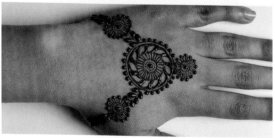

2. Outline the leaves with a thick line and fill in any gaps between each leaf so that only the insides of the leaves remain unfilled. This makes a negative space. Create two faint guidelines extending from the center flower to the sides of the hand. In the center of each of

the guidelines, draw one simple flower. Next, draw leaves on each side of the guidelines. Add a small flower on top of the center flower, and add dots around both of the side flowers.

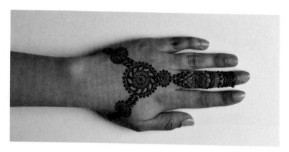

3. Draw two vines of leaves flowing onto the middle finger in a V shape, followed by alternating thick and thin lines. Continue layering with simple flowers, petals, and dots until you reach the top of the middle finger.

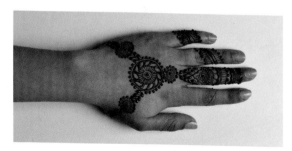

4. Complete the rest of the fingers with diagonal thick lines on each finger. Outline with two thin lines and draw petals on the thin lines. Layer the petals with dots.

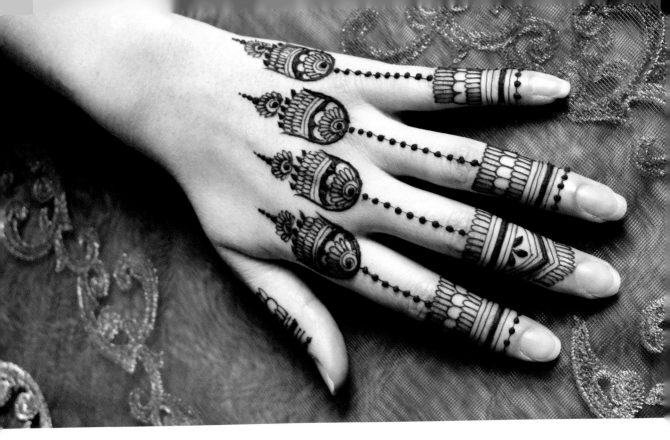

EARRING-INSPIRED MOTIFS

A quick and easy design inspired by Indian earrings creates striking motifs.

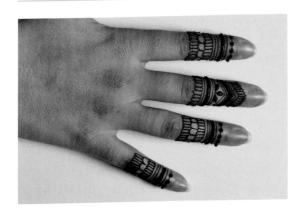

1. Start with some line work from the tip to the middle of each finger, using a variety of lines and petals.

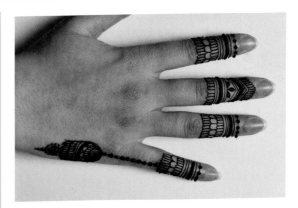

2. The first earring motif will be created on the little finger. Draw a dotted line from the bottom of the design on the little finger to the bottom knuckle. This

creates a chain-like effect. To draw the motif, create a dome shape, which is typical of Indian earrings. Ensure the sides of the shape flare out slightly. Begin filling in the motif from the top by creating a simple flower within it and layering it until the entire shape is filled. Finish the motif with a small flower at the bottom, as well as some dots.

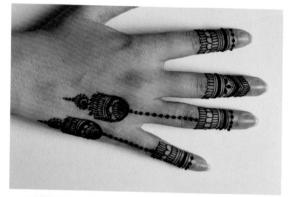

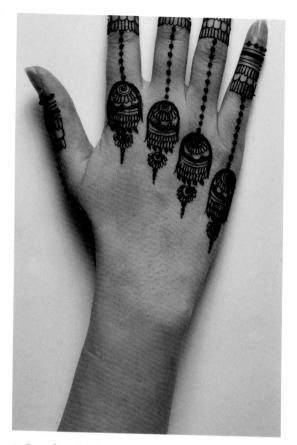

4. Complete the design by repeating the same pattern on the thumb.

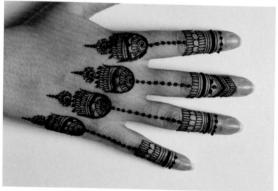

3. Continue the same pattern on the rest of the finger, ensuring that each motif is drawn slightly higher than the last as you move toward the index finger. The motif on the little finger will be further down the hand than the motif on the index finger. The difference in height will give a unique look to the design and ensure the motifs are arranged in the form of a diagonal line instead of all being at the same level.

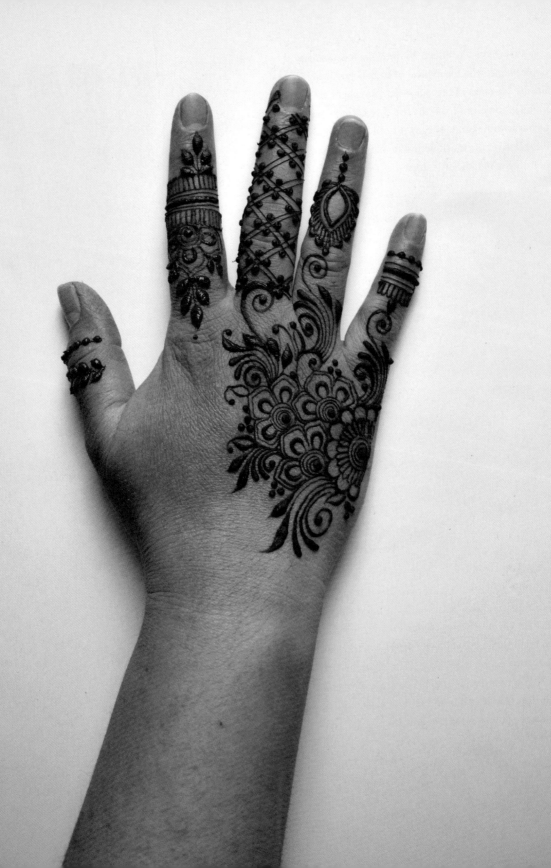

SIMPLE FLORALS

A simple floral design at the side of the hand with some finger details creates a trendy and stylish look.

1. Draw a flower near the outside of the hand with thin and larger petals. Add a swirl and some leaves joined to the flower.

3. Layer swirls and leafy vines around the flowers, with some flowing onto the little finger and ring finger.

2. Layer three more flowers around the larger flower with thick round petals on the inside of larger petals. Make leaves around the flowers.

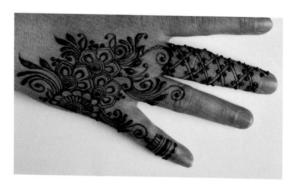

4. Fill the middle finger with lines crossing each other to create a netting effect. Where the lines cross each other, add a dot in each corner.

5. Add various intricate details on the rest of the fingers. Use line work and dots on the top of the little finger; a teardrop shape with dots on top of the ring finger; and some line work with a flower and leaves on the index finger. Make a dotted line and line with leaves on either side on the thumb to complete the design.

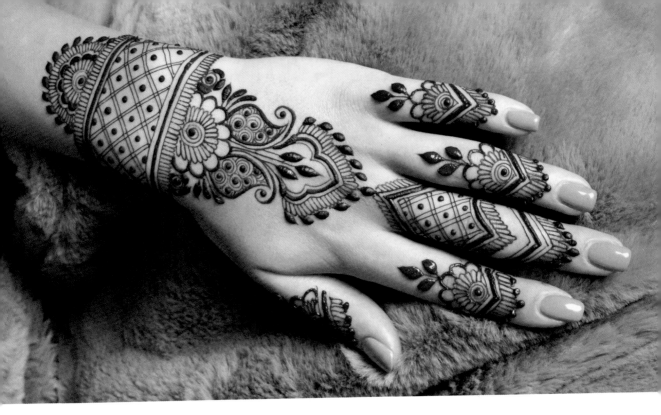

NETTING AND FLORALS DESIGN

This beautiful design includes lots of florals and paisleys connected to a bracelet-like net design on the wrist, as well as intricate details on the fingers.

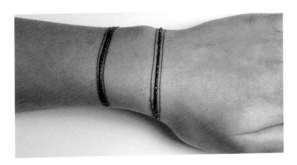

1. Begin by drawing two thick lines on the wrist and leaving a fair amount of empty space in between them for the netting fill. Outline both of these thick lines with two thin lines.

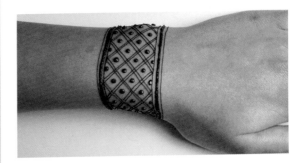

2. Fill the empty space with lines crossing over each other to create a netting effect, with dots in the middle of each square.

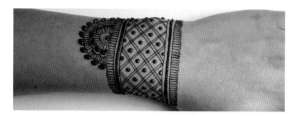

3. Draw thin petals on the outer lines of this fill. Draw a simple flower on the petals toward the arm, making sure it is aligned with the center of the hand. Outline the flower with thicker petals and then thinner ones. Finish the flower with filled leaves around it.

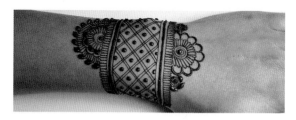

4. Draw another simple flower on the other end of the netting and outline it with thick petals. Then draw two small roses at each side of this flower.

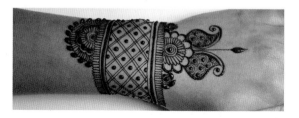

5. Draw two even paisleys on top of the big flower and fill the paisleys with round swirls and dots, then outline them with a thicker line and two thinner lines coming from the back of each paisley, with one central line in between them.

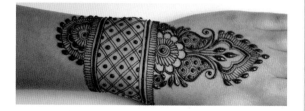

6. Draw three filled leaves coming out from the paisleys and outline them with thin and thick lines and small petals. Draw filled leaves on top of the petals.

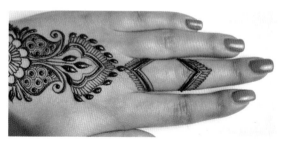

7. Create a V shape at the bottom of the middle finger and connect it to the center leaf. At the middle knuckle, draw a V shape in the other direction so there is an empty space between them.

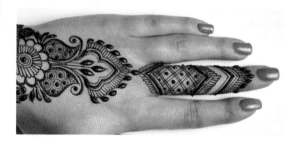

8. Fill the empty space with the same netting fill as on the wrist. Continue creating thin and thick lines with petals until you reach the top of the finger.

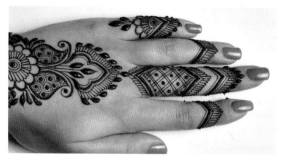

9. On the rest of the fingers, create a V shape pointing toward the nail, and outline it with a thick line, thin line, and petals. On the inside of the V, draw a simple flower with bigger petals and a set of three filled leaves attached to it.

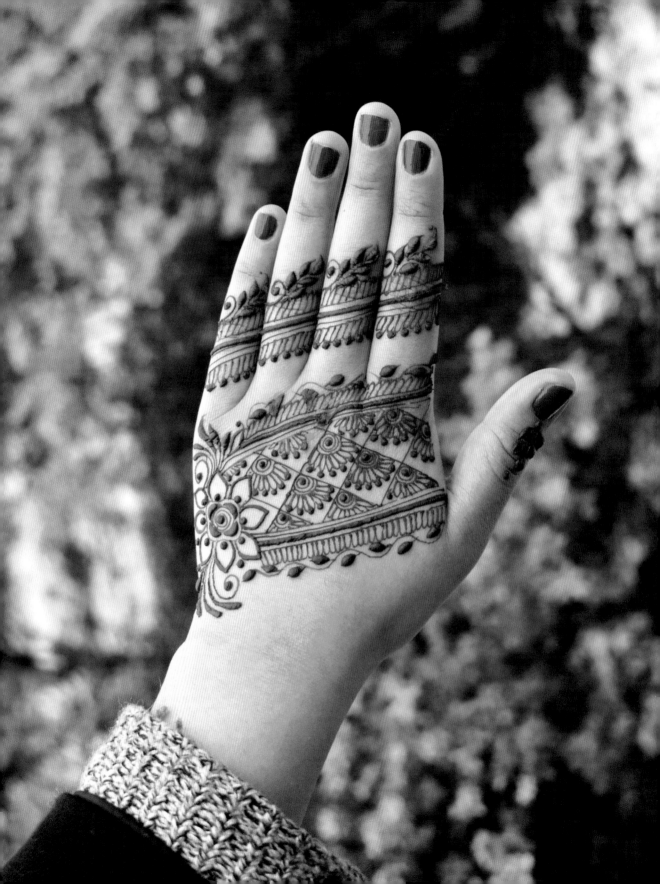

FLORAL GRID FILL

Grids and nets are very important elements in henna designs that can be used to connect other elements or fill in spaces. These have become more popular recently and many different forms have developed. In this design, the squares in the grid are filled with flowers to create an intricate and distinctive design.

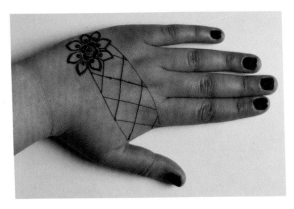

1. Make a flower at the outside of the hand. Draw a diagonal band of empty space. Fill the space between the lines with evenly spaced grid lines.

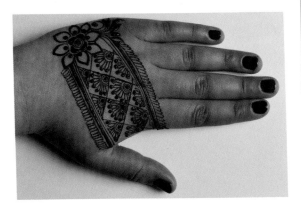

2. Add a simple flower within each square of the grid. Outside of the grid, make thick and thin lines trailed by petals, and wavy lines with leaves in each curve.

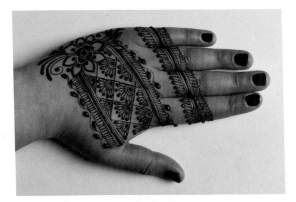

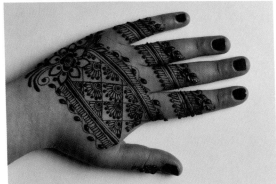

3. Make another thick diagonal line on the finger that goes parallel to the design on the hand. Add thin lines above and below the thick line, followed by petals and leaves.

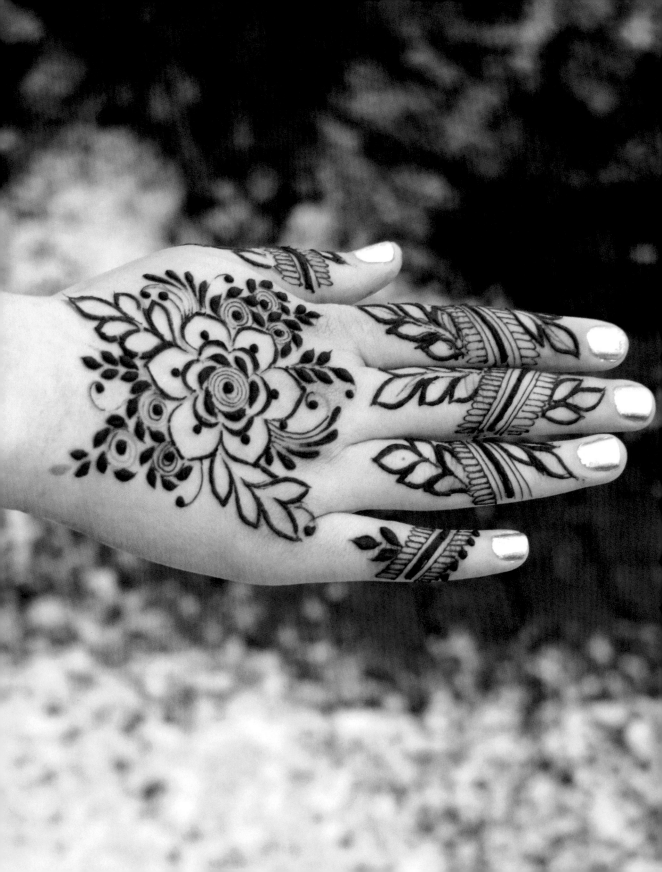

FLOWER MOTIF AND BOLD LEAVES

This exquisite floral design with large, bold leaves is easy to do, and ideal for parties and events.

1. Start with a rose in the middle of the hand. Layer larger leaves around it to create a beautiful flower.

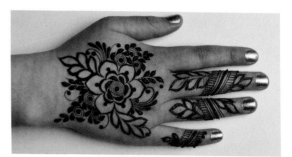

2. Make two sets of three roses around the main flower.

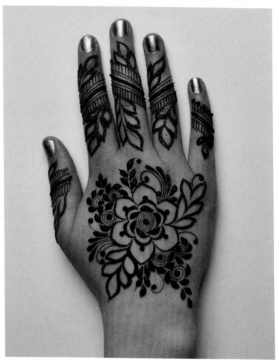

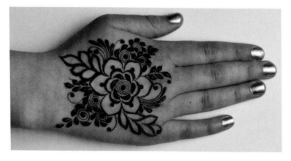

3. Draw large unfilled vines of leaves with thick outlines around the flower. Add some filled leaves to create more detail.

4. Make diagonal lines on each finger, with the lines alternating directions. Use a variation of lines to build the designs on the fingers. Create the same unfilled large leaves on the fingers to coordinate with the design on the hand.

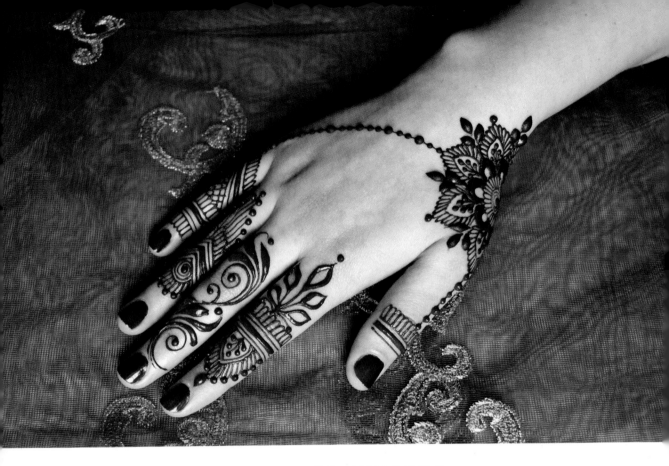

DETAILED FINGERS

The main focus of this design is on the uniquely decorated fingers and the main flower motif at the side of the thumb that connects to the little finger with a dotted line. This design is easy to do, yet creates an interesting look due to the different patterns.

1. Draw a simple flower on the side of the hand near the thumb, and layer it with thick petals and then larger petals. Fill the largest petals with some lines, each ending in a dot.

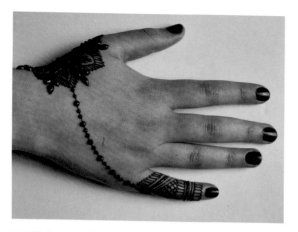

2. Fill the space between the larger petals with three filled leaves. Draw some thick and thin lines on the little finger. Create a space to fill with netting by creating a V shape at the bottom of the little finger. Join the point on the V shape with one of the larger petals on the flower by drawing a dotted line across the hand.

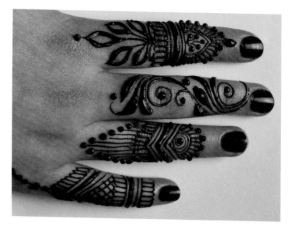

4. On the middle finger, draw swirls followed by bold, leafy vines. Draw thick and thin lines at the center of the index finger. On the top line, toward the nail, create one of the larger petals from the flower motif. Complete the rest of the index finger with a set of unfilled leaves.

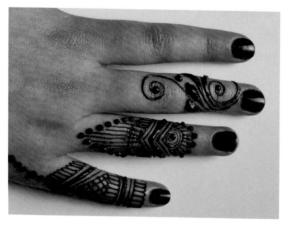

3. Draw another V shape on the ring finger. Outline with thick and thin lines. Draw a small flower within the V, closer to the nail. Draw thin lines extending down the finger, making the lines shorter closer to the sides of the finger. End each line with a dot.

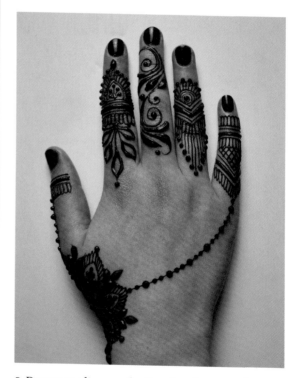

5. Draw some lines on the thumb and connect them to the flower motif on the hand with a dotted line.

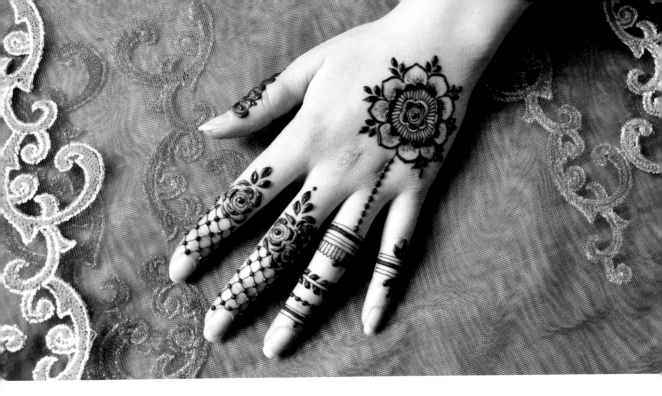

QUICK FLOWER DESIGN

A beautiful, eye-catching design portrays a bold rose at the
side of the hand and intricate designs on the fingers.

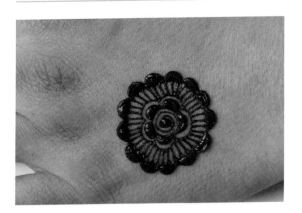

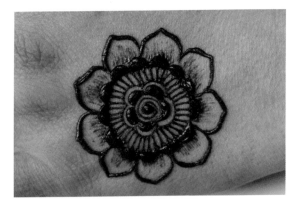

1. Draw a small rose on the side of the hand. Build the
flower with thick and thin petals. Finally, create larger
petals around the entire flower and shade them in.

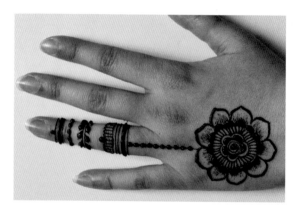

2. Make a line at the center of the ring finger. Using a dotted line, join the top of the flower to the line drawn on the finger. Create thick and thin lines and a vine of leaves on the top of the finger.

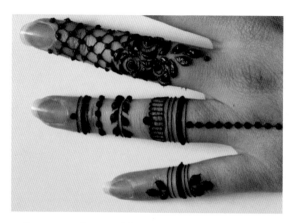

3. Draw some lines and leaves on the little finger. For the middle finger, make a boundary of roses just below the center of the middle finger. Fill in the space above the roses with netting. Place a dot where the lines meet.

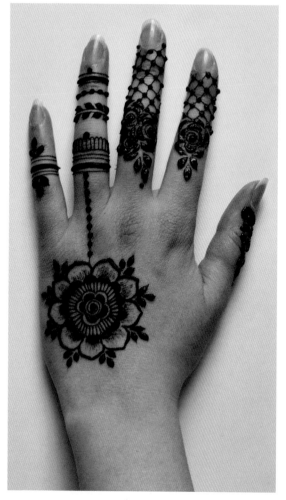

4. Repeat the same roses and netting design on the index finger.

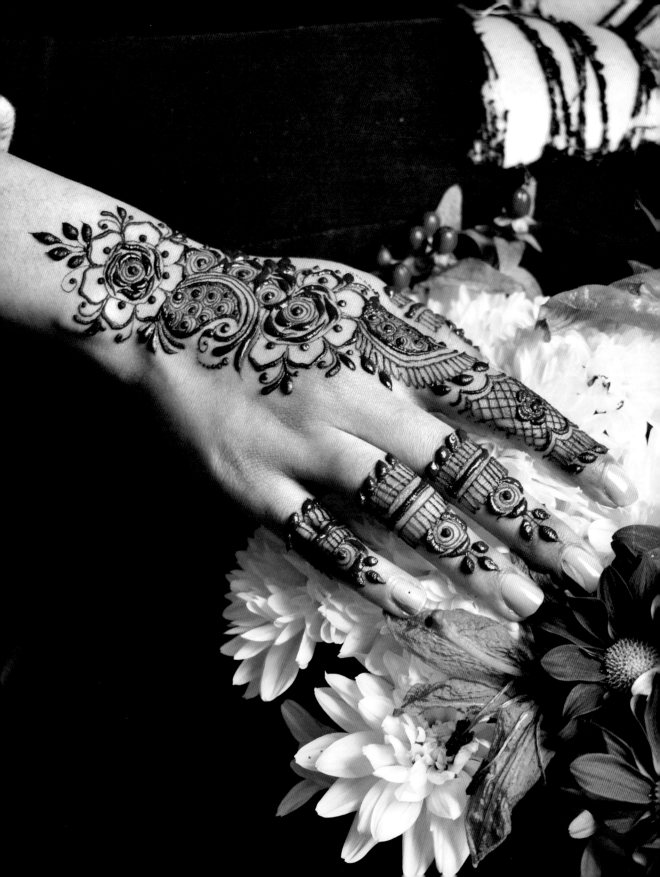

SIMPLE STRIP DESIGN

This classic Indian design is a strip of pattern that flows from the wrist to the index finger. It can easily be built up with more detail and intricacy on the fingers and arm.

1. Start with a simple rose at the wrist.

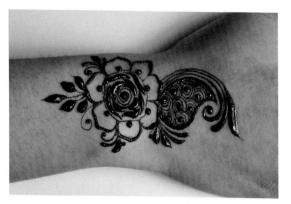

3. Now draw a paisley, filled with swirls and dots, on the other end of the flower, flowing toward the hand.

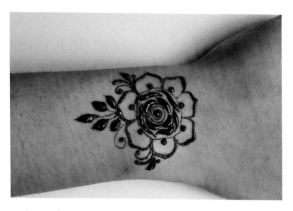

2. Create bigger petals connected to the rose and some filled leaves extending from the top of the flower toward the arm.

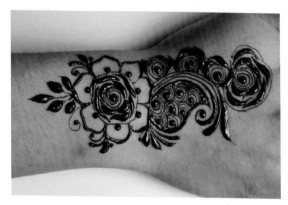

4. Draw some roses connected to the back of the paisley and a larger rose on the top.

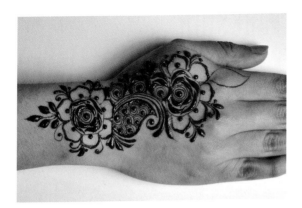

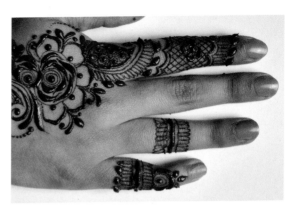

5. Draw the same big petals around the last rose and a smaller paisley joined to the top of this flower.

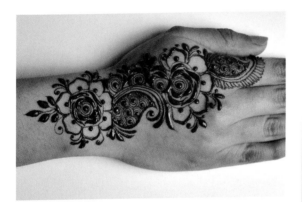

6. Fill the smaller paisley with swirls and outline it with smaller petals.

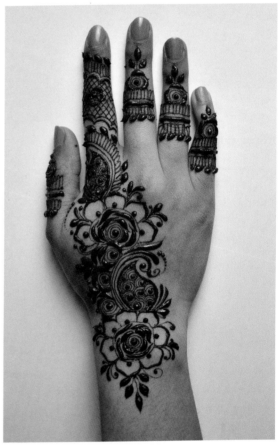

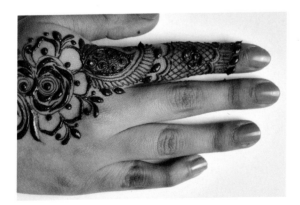

7. Fill the rest of the space on the index finger with some netting design, small petals, and filled leaves.

8. Crate a thick, bold line in the middle of each finger surrounded by two thin lines. Draw small thin petals on the thin lines. On the top lines, toward the nail, draw a rose with a set of three leaves attached to it, and on the bottom lines, draw some filled leaves.

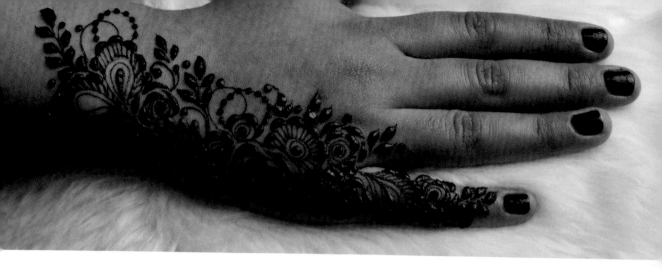

ELEGANT DESIGN ON SIDE OF HAND

This free-flowing design placed on the side of the hand incorporates many different elements to create an elegant and minimal look.

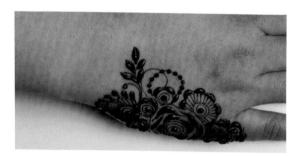

1. Draw various different flowers like roses and simple flowers with thin long petals at the outside of the hand.

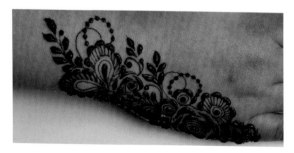

2. Continue building the design on to the wrist until the preferred finishing point is reached. Add teardrop

shapes with petals and leafy vines to make the design more detailed.

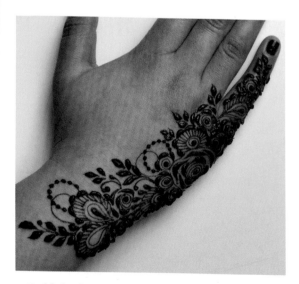

3. Build the design upward onto the little finger. Ensure the design is kept on the side of the hand and does not come too far into the middle of the hand.

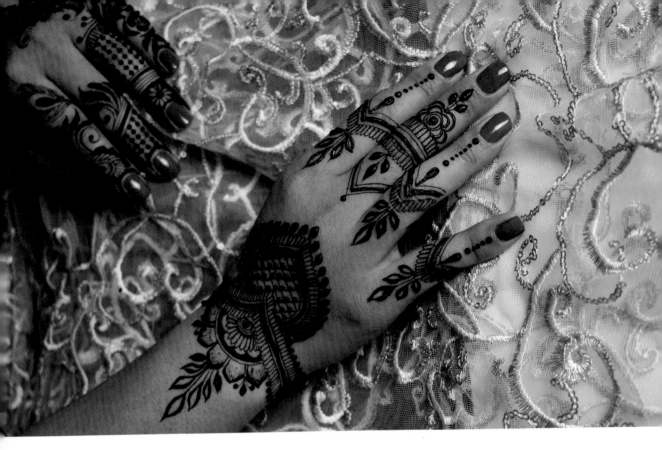

SIMPLE MODERN DESIGN

This is a simple structured design using various elements. This design is
quick and easy to do yet looks very elegant and modern on the hand.

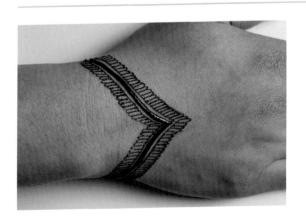

1. Start by drawing a V shape at the bottom of the hand
with the point facing upward. Use the sides of the wrist
and the middle finger as guides to ensure the V is even
and symmetrical. Then thicken the line and create
thinner lines above and below it. Draw thin petals on
the thin lines.

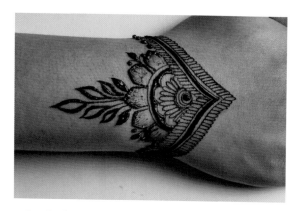

2. Inside the V shape, draw a simple flower with larger shaded petals and a set of leaves extending toward the arm.

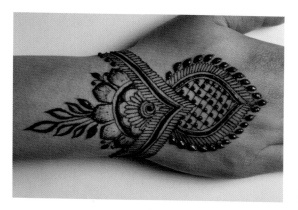

3. On top of the hand, draw a pointed dome shape joined to the V, again using the middle finger as a guide to make it symmetrical. Fill this shape with lines crossing each other to create a netting effect and fill each square in the net with a dot. Outline the dome shape with another line, simple petals, and filled leaves going all the way around it.

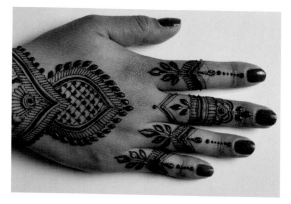

4. In the center of the middle finger, create a thick line surrounded by thin lines. Draw petals on the thin lines. On the top line of petals draw, toward the nail, a flower, and on the bottom petals, draw a set of three filled leaves extending toward the dome shape. Under the leaves, create two thin lines in a downward V shape.

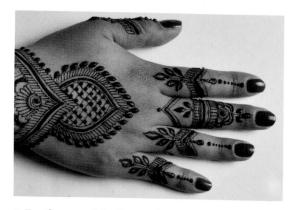

5. For the rest of the fingers, draw downward-facing V shapes using thick and thin lines and petals. Within the V shapes, draw some dots flowing toward the fingernails. On the point of the V shapes, draw a set of matching leaves as on the wrist, flowing downward on the hand.

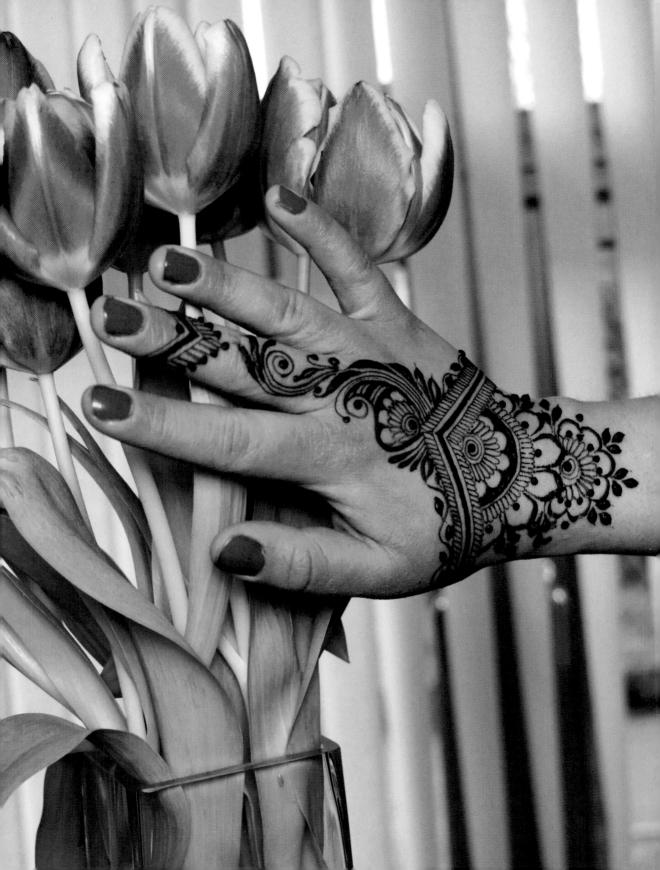

MODERN FLOWER AND PAISLEY DESIGN

This gorgeous party design is a structured combination of floral and paisley elements that portray a modern and stylish look. The main focus is kept on the design on the hand.

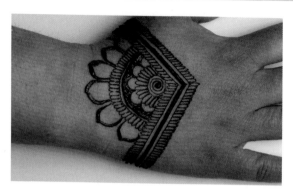

1. As in the Simple Modern Design (page 48), the first step is to draw a V shape at the bottom of the hand with the point facing upward. Use the sides of the wrist and the middle finger as guide to ensure the V is even and symmetrical. Then thicken the line and create thinner lines above and under it. Draw thin petals on the thin lines.

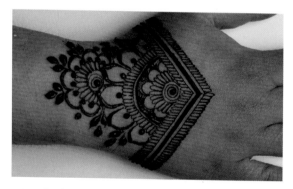

2. Inside the V shape draw a simple flower, layering it to form a bigger flower with larger petals. You can change up the petals according to preference (e.g., heart-shaped, round, or curved, pointy petals).

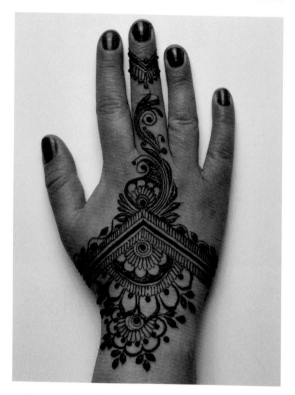

3. Draw another flower under the main flower and surround the sides with sets of leaves. On top of the V shape, create a paisley. Fill the paisley with desired elements (like a flower, pictured here). Layer thin lines that end with leaves at either side of the paisley. Draw a swirl from the paisley that flows onto the middle finger, and add leaves. Finish the design on the middle finger with a variety of lines in the form of a small V shape. On the sides of the V in the middle of the hand, draw wavy lines. Add a leaf within each curve of the wavy line. Small details can also be added on the other fingers if desired.

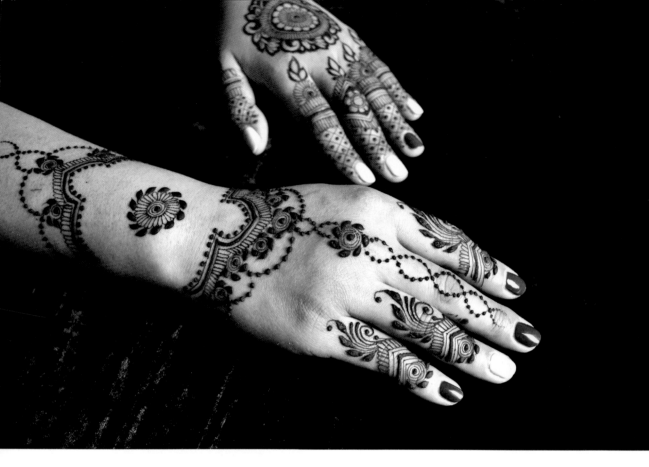

SIMPLE ROSES AND DOTS DESIGN

A simple design that incorporates delicate roses and dotted lines. This design is perfect for a simple yet elegant look on the hand.

1. Using curved lines, create a boundary line where the hand and wrist meet. To do this, draw two curved C lines starting at the sides of the wrist and join them in the center with a curved upward V line. Outline with thin lines. Leaving an inch of space below the curved element, draw a simple flower with bold petals around it.

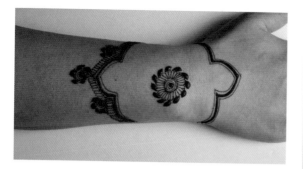

2. Leave the same amount of space below the flower and draw the same curved element as on the wrist. Draw a line of petals on the outer line and one rose at each of the three points where the curved lines meet.

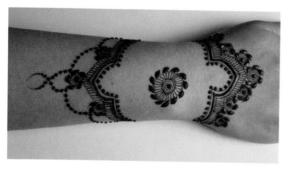

3. Draw a line of petals along the outside of the curved line element on the wrist, adding a few extra roses on it. Draw dots on the lines on the inner part of the element. On the lower curved element, draw dotted lines connecting the roses to each other.

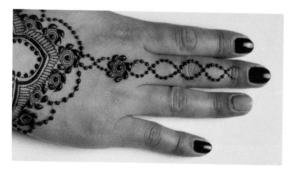

4. Draw another rose just below the middle finger. Now draw two dotted swirly lines starting at the center rose, intertwining and extending to the top of the middle finger.

Connect this to the other roses along the curved element.

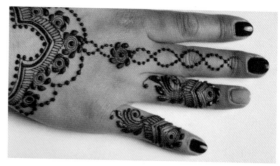

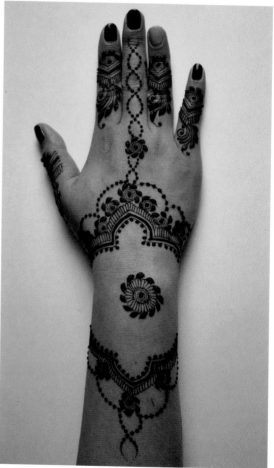

5. Create simple V shapes on the fingers using lines and petals. Create roses within the V shapes to complement the design on the hands. At the bottom of each V, draw a swirl and some leafy lines.

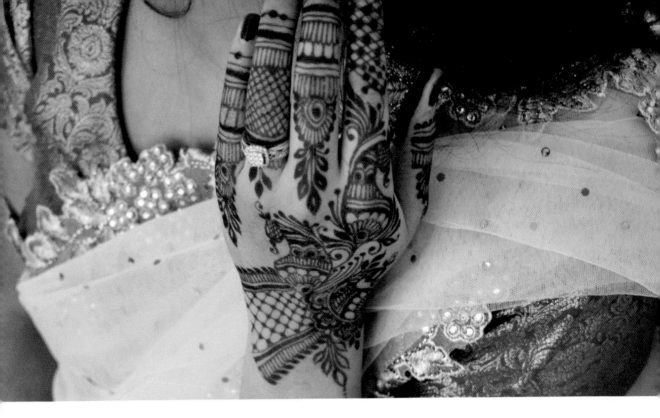

PAISLEY PEACOCKS

This elegant design, which can be completed in a short time for an occasion or party, presents a trio of peacocks in the form of paisleys often used in Indian henna designs.

1. Draw a paisley in the center of the hand with a round head at the top, rather than the usual pointy end. This will be the head of the peacock. Fill the paisley with different elements like flowers and line work. Fill the round head with netting and draw a very small paisley with a swirl joined to the head.

2. Make lines extend from the bottom of the paisley to about halfway around it. End each line with a dot. Draw some leafy vines around the paisley, and two leaves and a swirl at the top of the round head.

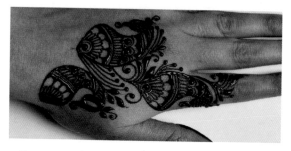

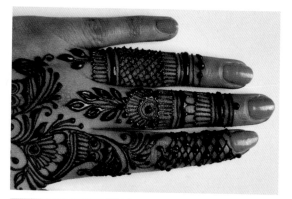

3. Draw a similar paisley peacock on the upper side of the hand extending on to the index finger, and another at the bottom of the hand near the thumb. The second one should have a filled head with empty space to show the eye of the peacock.

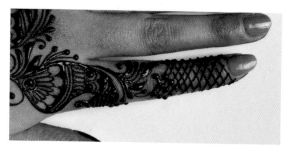

4. Create some leaves and netting to complete the index finger and some flowers on the back of the third paisley. Draw two diagonal parallel lines from the center peacock to the other side of the hand, leaving a couple of inches of space between them. Outline with thin lines.

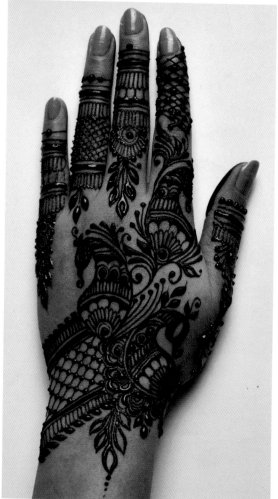

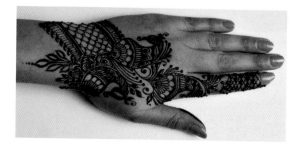

5. Fill the space between the lines with a grid form to create a netting effect. Place a dot at each point where the lines meet. Add a line of thin petals along the outer edges of the netting strip, followed by leaves.

6. Create different designs on each of the fingers using line work, flowers, netting, and sets of leaves.

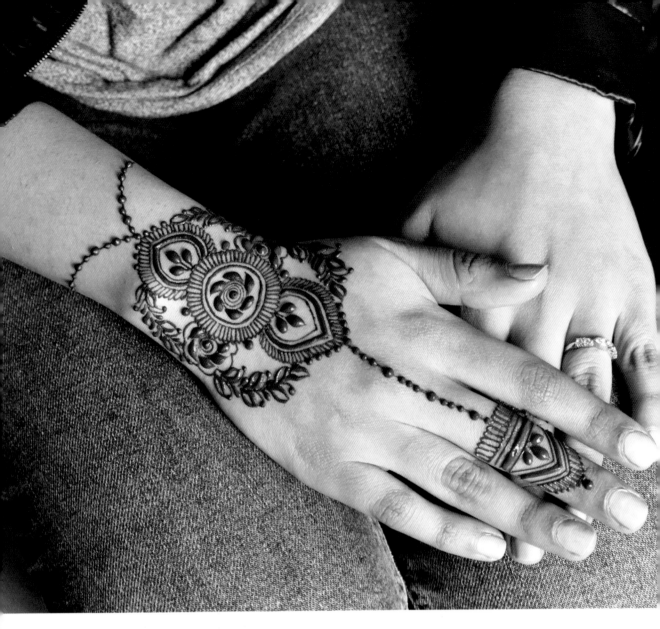

INTRICATE WRIST DESIGN

Sometimes creating intricate work on the wrist while leaving the rest
of the hand empty produces a very stylish and modern look.

1. Start with a small rose slightly above the wrist. Outline the rose with a thick and thin circle and petals around it.

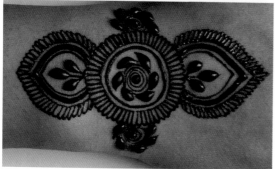

2. Draw a set of three leaves below the circle. Outline the leaves with a pointed dome shape and layer with lines and petals. Do the same on the top of the circle, going onto the hand. Draw a rose on both sides of the circle.

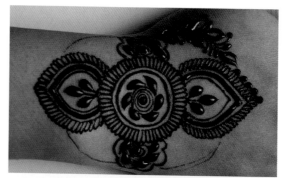

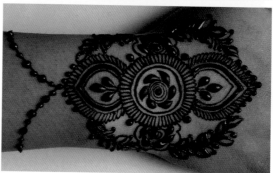

3. Join the roses with the dome shape motifs by a vine of unfilled leaves and swirls. Add dots at the side of each rose. Finish the design on the wrist with two dotted lines extending out from the point of the dome shape to the side of the arms.

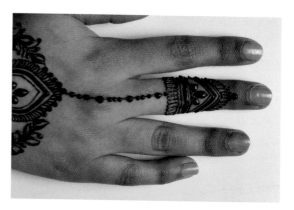

4. Create thick and thin lines with petals on the middle finger and an inverted V shape on top. Add three leaves inside the V shape. Connect this to the wrist design with a dotted line running down the middle of the hand.

DETAIL AND INTRICACY

This chapter will show you how to build on simple designs and create more intricate ones. You'll find a variety of more detailed patterns and styles of henna designs here than in the previous chapter.

Three Styles of Henna

Indian-style henna involves many different elements covering the hand, including peacocks, paisleys, flowers, leaves, and other motifs. These designs may also have a central motif like a mandala, which is a round-shape that is built of layers around which the rest of the design is formed.

Arabic-style henna is very free-flowing and includes various types of bold flowers with thick petals and leaves. This style stands out the most with its bold yet delicate patterns due to the variations in pressure applied to the henna cone. Unlike Indian henna, Arabic henna designs do not cover the hands completely, but focus on different parts of the hands such as the side and leave the other areas empty or minimally covered.

Moroccan-style henna uses straight lines, dots, and triangle and square shapes to form geometric patterns. If you are a beginner in henna, then practicing using the Moroccan style may be easier for you than the other henna styles. Moroccan henna design can make gorgeous structured patterns that resemble a bracelet on the arm or wrist.

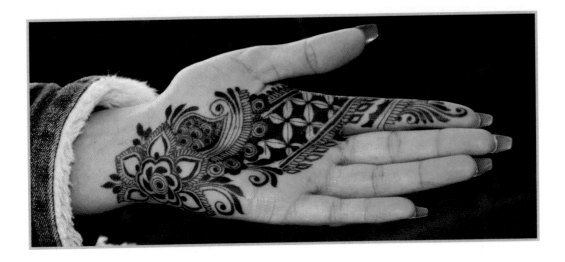

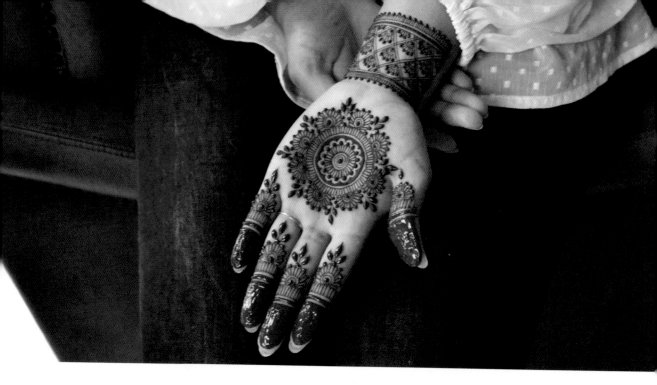

SIMPLE MANDALA DESIGN

This is a classic design that looks great on the hands and the feet. A simple mandala like this can be created on its own, as shown here, or paired with designs on the fingers and wrist to give a more detailed and interesting appearance.

1. Draw a dot in the center of the hand and use it as a guide to draw a simple flower (page 18) with dots around it.

2. Outline the dots and create another line around this outline.

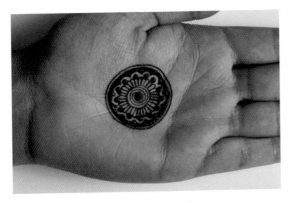

3. Fill in the space between the two lines.

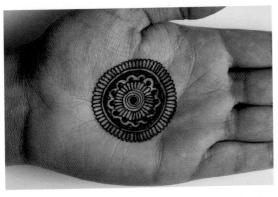

4. Draw another circle outlining the whole motif and create petals all the way around the circle.

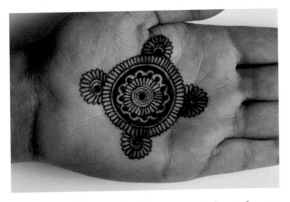

5. Next draw four simple flowers around the circle, one at the top, one at the bottom, and one on each side. You can use faint lines as guides so that they are centered and placed evenly around the motif.

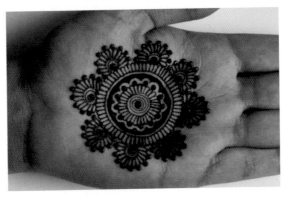

6. Now draw flowers in the empty spaces between the flowers you have already created. There should be eight flowers in total around the circle. Add dots around each flower.

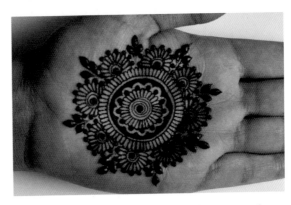

7. Create a set of three small leaves in between each flower, applying pressure on the henna cone and releasing to create each leaf.

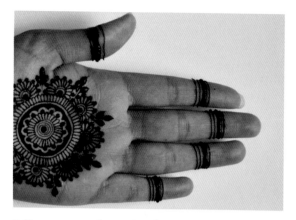

8. To create complementing designs on the fingers, draw a variety of thick and thin lines at the tops of the fingers.

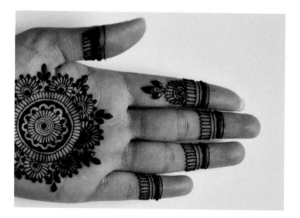

9. Around the bottom line on each finger, draw small petals coming down the fingers.

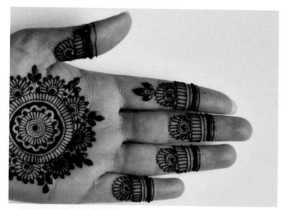

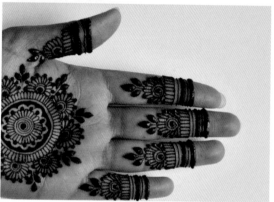

10. Draw a basic flower after under the small line of petals adding a set of three leaves coming down from under the flower.

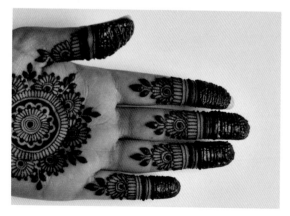

11. Fill in the tips of the fingers completely with henna.

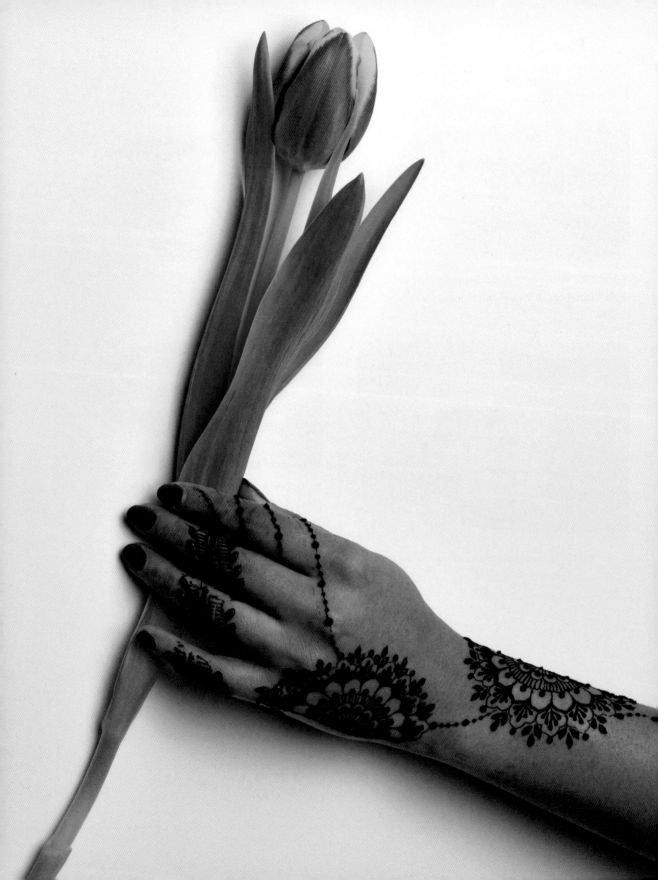

SEMI-MANDALAS

A mandala can be drawn in many ways and using various elements. This understated design was created using half mandalas and minimal details on the fingers.

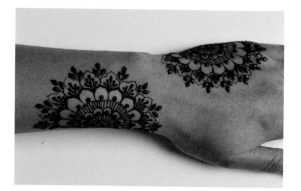

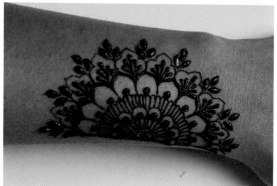

2. Repeat the same semi-mandala pattern on the outside of the hand, ensuring the mandalas are opposite each other.

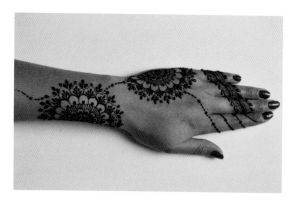

1. Start with a half flower at the inner side of the arm below the wrist. Keep layering the flower with different-sized petals and elements until the resulting semi-mandala is fairly spread out on the arm.

3. Finally, connect the semi-mandalas with a dotted line that twists around the index finger. For the rest of the fingers, create a thick diagonal line with thin lines and petals around it. Layer the petals with filled leaves.

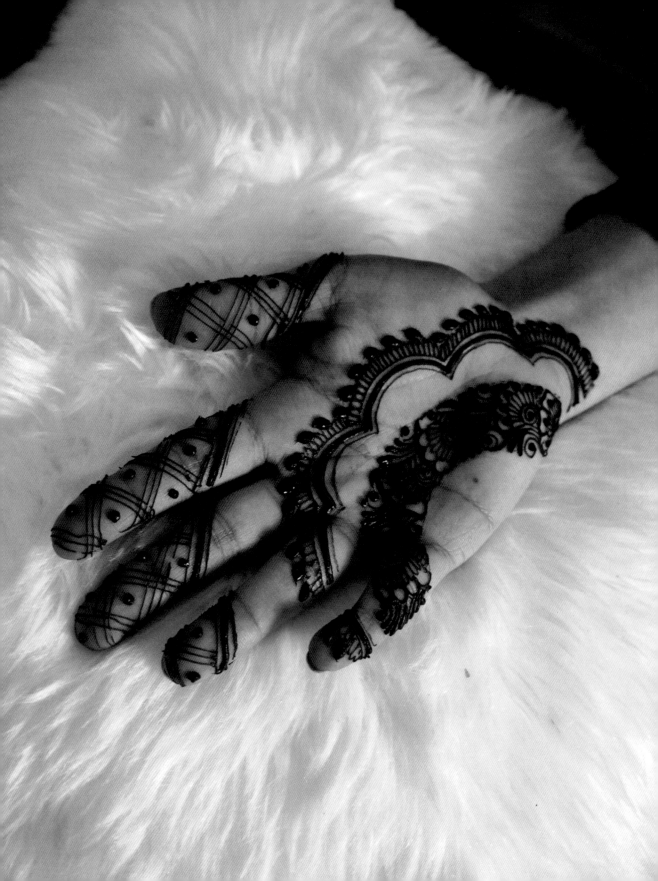

SEMICIRCLE STRIP DESIGN

This semicircle starts off small and expands over the hand with intricate layers and netting.

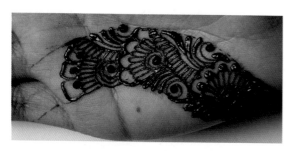

1. Create a semicircle strip of intricate design at the outside of the hand on the palm. Make faint guidelines to ensure the design is kept within the strip. The design inside the strip is a combination of flowers and leaves closely joined together.

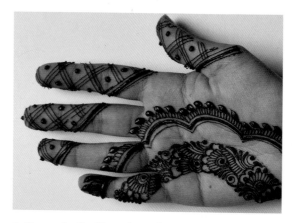

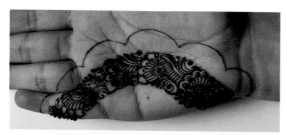

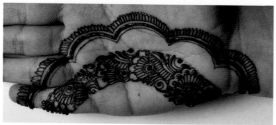

2. Leave some space and create another semicircle layer. This can be straight or, in this case, a scalloped line with curves. Create more layers on this line using a combination of thick and thin lines trailed by petals and leaves.

3. Create the final layer by making a thin line following the shape of the other lines and stopping in the center of the thumb. Layer the line with thick and thin lines. Fill the rest of the space behind the line with a netting effect. Put a dot in each square of the net.

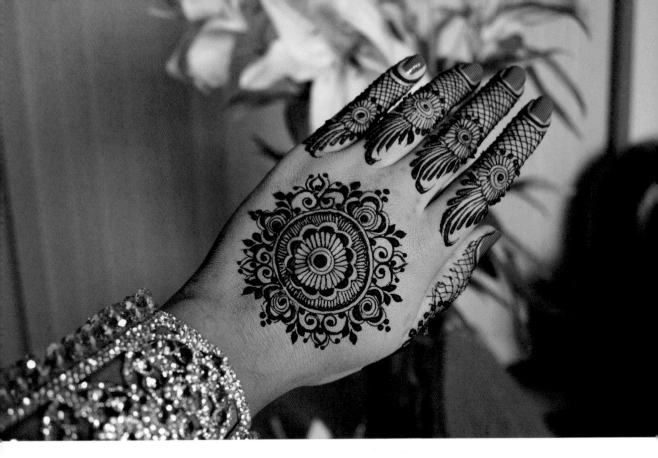

INTRICATE MANDALA DESIGN

Mandalas can be formed using many different variations of flowers and elements. This design incorporates roses and swirls with intricate netting on the fingers to create a unique mandala pattern.

1. Create a flower in the center of the hand with bold petals around the edge.

2. Outline the flower and create a layer of thin lines going around it. This layer can be bigger or smaller as preferred. Outline the layer with a thick line.

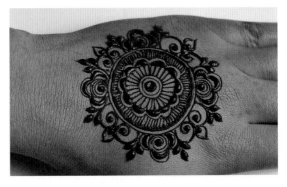

5. At the point where the swirls meet, draw a small empty leaf with a dot in it. In between the roses and the swirls, draw a set of three filled leaves.

3. Draw another thin outline around the whole motif and create four roses: one on top, one on the bottom, and one on each side of the center motif. Outline each rose with a thin line.

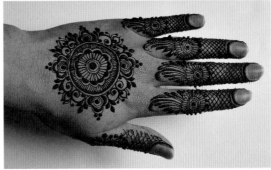

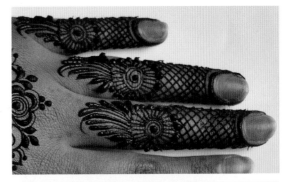

6. Draw a flower in the middle of each finger. Fill the space above the flower with lines crossing each other to create a close-knit netting. Below each flower, draw a set of lines that elongates into thick leaves at the end. Ensure the lines are longer toward the middle of the fingers and shortest at the sides of the fingers.

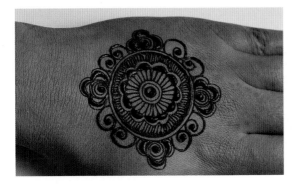

4. In each of the spaces between the roses, create two swirls facing each other.

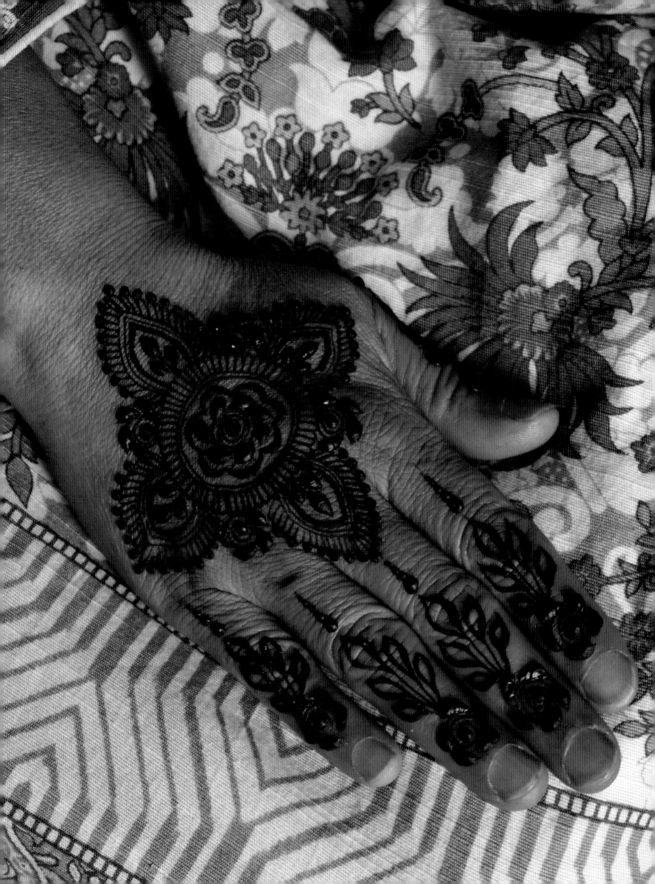

ROSES AND LEAVES MOTIF

This design is formed around a central rose in the middle of the hand with four dome-shaped elements around it.

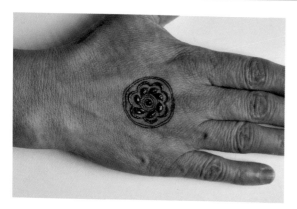

1. Make a rose in the center of the hand and outline with a thick line.

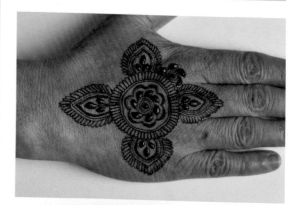

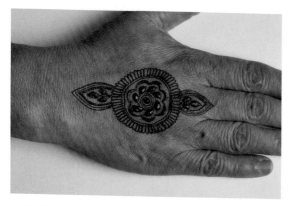

2. Outline the rose with two thin lines trailed by thin petals around them. Create a set of three filled leaves with a pointed dome shape around them on the top and bottom of the outer line. Outline the dome elements with thick and thin lines.

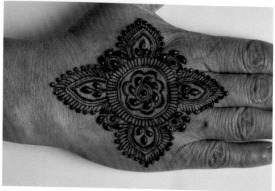

3. Make the same dome shapes and leaves at either side of the rose motif, and outline the outer edges of the domes with thin petals. Add small roses in the spaces between the dome elements.

4. Create roses on the fingers with a set of five unfilled leaves followed by dots to complement the motif on the hand.

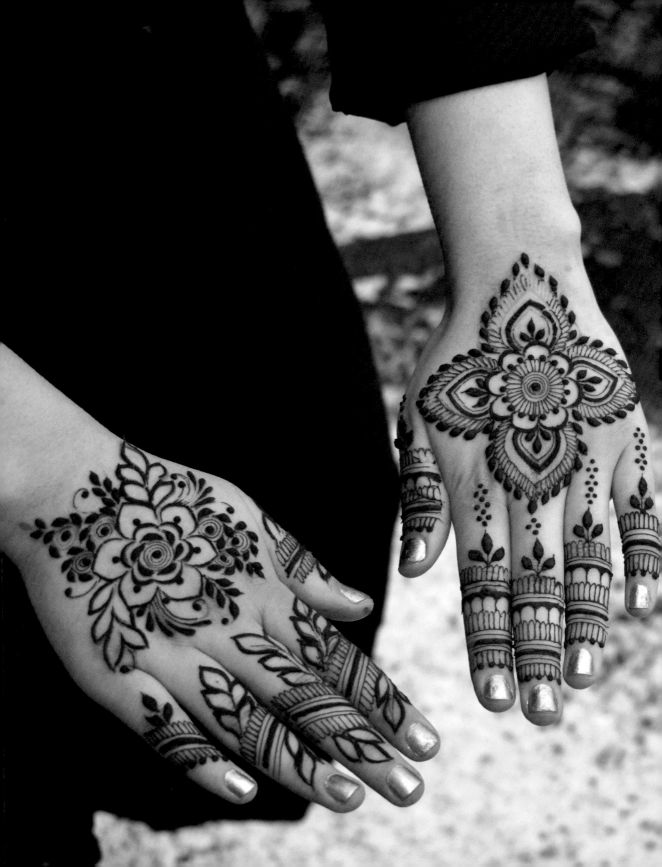

DETAILED MANDALA-STYLE MOTIF

This unique motif is based on a flower in the middle with four dome-shape elements around it. Although not round, it reflects a different take on the typical mandala-style designs. The intricate fingers complement the motif perfectly while still maintaining focus on the mandala.

1. Create a flower in the middle with dots around it. Surround the flower with thick, wide petals.

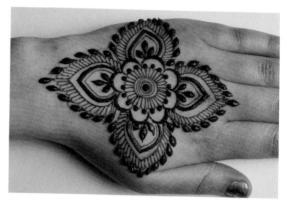

3. Surround each dome with leaves.

2. Draw four pointed dome shapes, evenly spaced around the flower. Create a set of three filled leaves in each dome. Use line variations and thin petals to make the domes bigger.

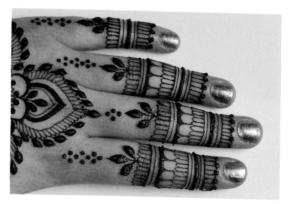

4. To keep the fingers simple yet intricate, use variations of lines and petals, and add leaves at the bottom of each finger. Add some dots below the leaves.

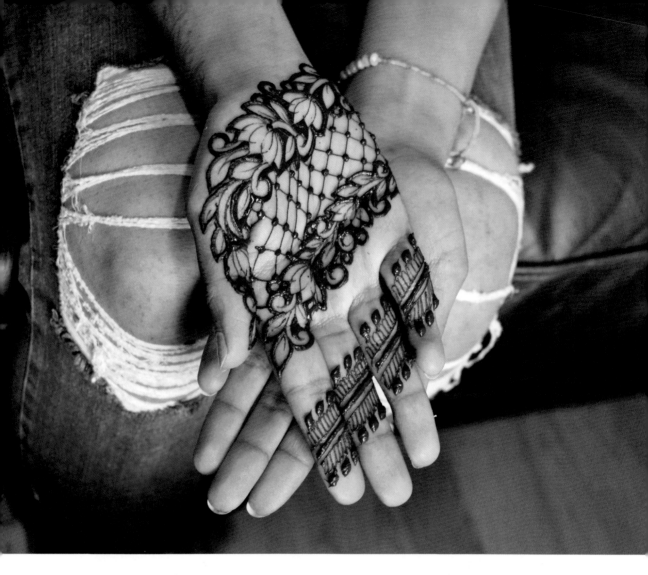

REVERSE NEGATIVE SPACE DESIGN

This technique known as reverse negative space has taken over henna designs recently. Negative space is the area surrounding the main pattern of henna. Reverse negative space is created by first drawing an outline of a floral or leafy pattern. Then the space around the pattern and between the different shapes is filled with henna, leaving the pattern empty so it can be clearly seen. This technique works well combined with other elements and can be incorporated in designs in many different ways to give a unique look to the overall design.

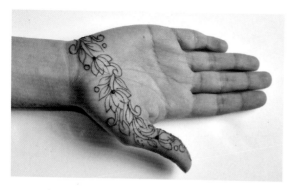

1. Start by creating an outline of the pattern, which in this case is lotus flowers joined by swirls and leaves going across the bottom of the palm.

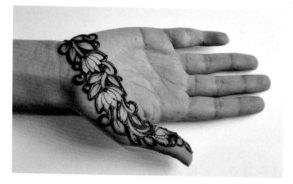

2. Create a bold outline around the outside of the pattern and fill in any empty spaces that are necessary for defining the elements of the pattern. The inner pattern and its elements should be left empty so they can be clearly seen once it has been outlined by an even, thick line.

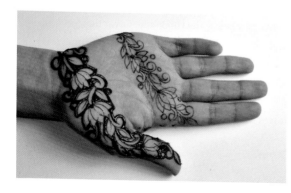

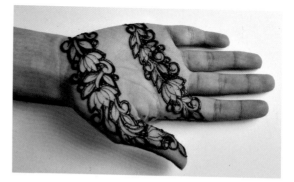

3. Create another pattern higher on the palm and parallel to the first, using the same reverse negative space technique.

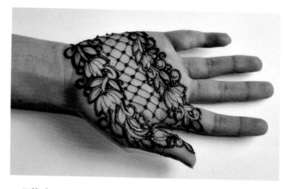

4. Fill the space between the two patterns with netting, with dots where the lines cross.

5. Finally, create a diagonal line on the fingers using thick and thin lines. Draw petals on the thinner lines and finish with filled leaves on the petals.

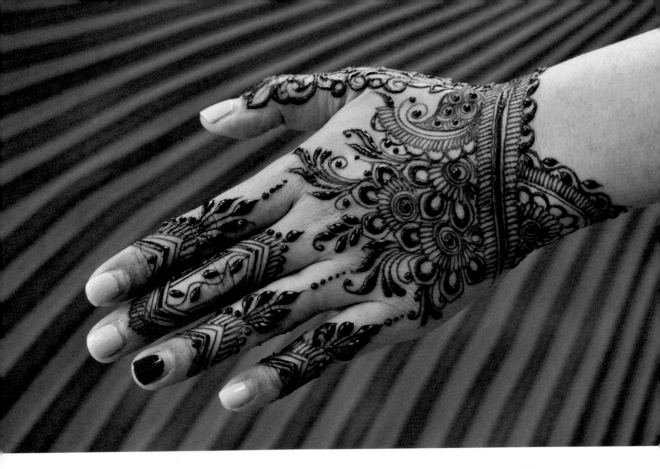

INDIAN-STYLE FLOWERS AND VINES

This full hand design has Indian flowers, paisley, and some reverse negative space elements.

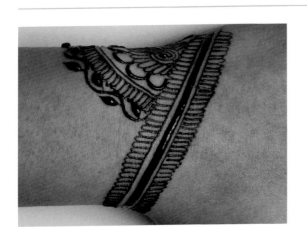

1. Draw a thick diagonal line from the inside of the wrist to the outside of the hand. Create two thin lines above and below the thick line. Layer the outer lines with thin petals. Draw another small diagonal line from the opposite side of the wrist, meeting the longer diagonal line. This leaves a small triangle at the side. Draw a flower in the triangle. Draw a wavy line and leaves on the outer edge of the line.

2. On the thumb, create a pattern that will be used for the reverse negative space technique, meeting the line at the wrist.

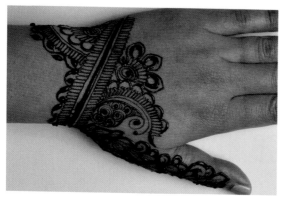

3. Draw a bold outline around the reverse negative space pattern so that the pattern can be clearly seen in the empty space left behind. Next to the reverse negative space pattern, draw a paisley and a flower with small and large petals.

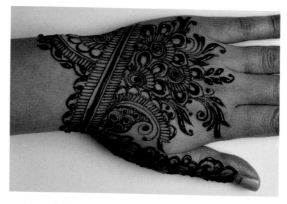

4. Around the flower, create two more similar flowers and leafy vines.

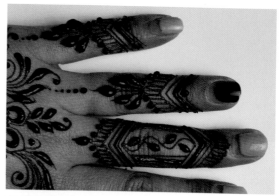

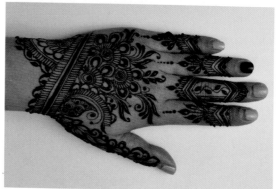

5. On the fingers, draw V-shaped thick and thin lines pointing down toward the hand with leaves at the bottom. For the middle finger, create V shape lines at the top and bottom. Add the same wavy line and leaves as on the wrist within the lines.

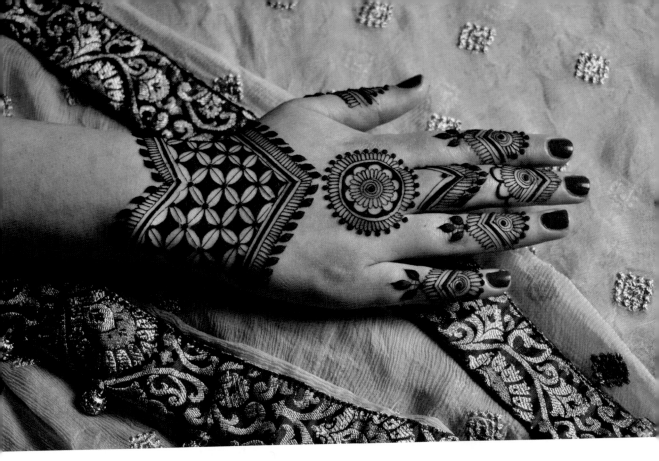

NEGATIVE SPACE NETTING

This features an area of negative space in a structured layout as the main focus, around which the rest of the design is formed. It is a striking modern design which is suitable for any occasion.

1. Create the main upward-pointing V shapes on the hand. The space between will be filled with a negative space pattern. Use a variation of lines to build layers around the shapes.

2. Create a netting effect by drawing evenly spaced lines crossing each other.

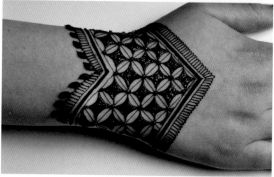

3. Now create the negative space pattern that will be left unfilled. This is done by drawing curved C shapes on the inside of each square in the netting. Fill in the rest of the unwanted empty space left in the middle of each square with henna so that the negative space will stand out from the rest. Create dots where the lines meet.

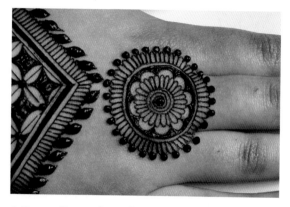

4. Draw a flower above the negative space area, building it up in layers to the desired size.

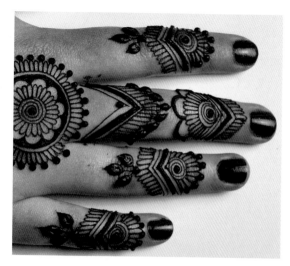

5. Create the same upward-pointing V shape on the fingers, outlining it with lines and petals. Draw a simple flower within the shapes and a set of leaves flowing down from the point of each V.

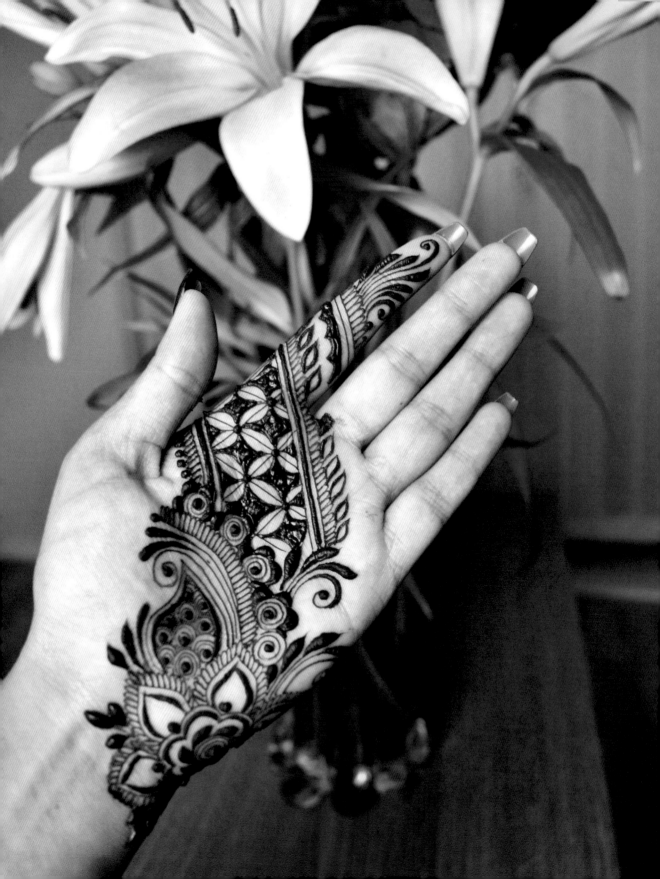

ELABORATE STRIP DESIGN

This elaborate design follows a typical strip layout and is formed by using intricate elements, negative space, and bold flowers.

1. Draw a basic rose at the side of the palm, building layers around it using thick and thin lines. Then draw a paisley joining onto the flower.

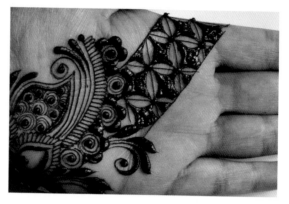

3. Fill in the space with negative-space netting (page 76).

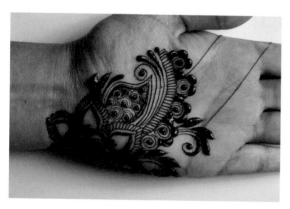

2. Outline the paisley with lines, and then draw a line of roses on the edge of those lines. Create some swirls and leaves in random areas around the flower and paisley. Draw two diagonal lines from the roses on the paisley toward the index finger. Leave a few inches of space between the lines.

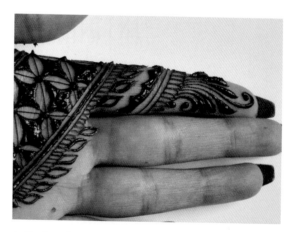

4. Outline the strip of negative-space netting with lines, petals, and leaves flowing onto the index finger. Last, create a swirl with varying lengths of leaves on the index finger.

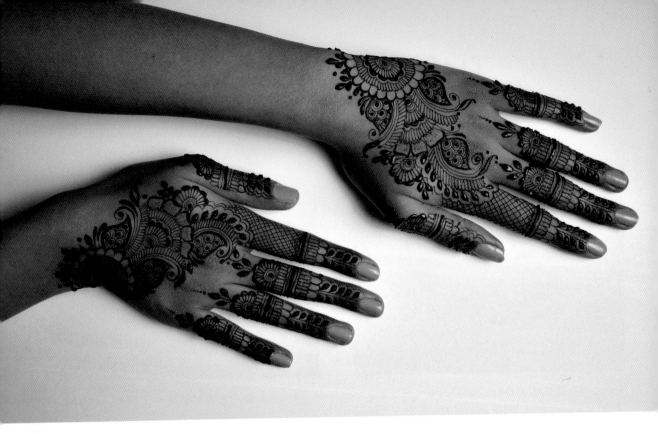

INTRICATE STRIP DESIGN

This is a more detailed version of the Simple Strip Design (page 45) with fuller designs on the fingers.

1. Draw a simple flower with bold petals at the outside edge of the hand.

2. Continue drawing thinner petals around the flower followed by larger ones.

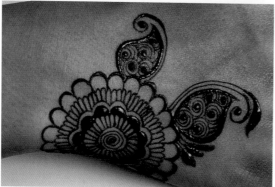

3. Draw two small paisleys above the flower, leaving a gap in between them. Fill the paisleys with swirls and dots.

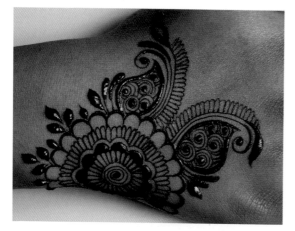

4. Outline the back of the paisleys with two lines, creating thin petals on the outer line. Draw some filled leaves around the flower to create detail.

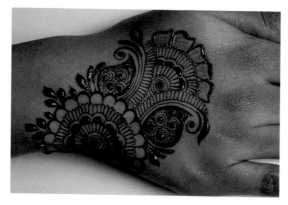

5. In the space between the paisleys, create a simple flower, building it into a bigger one with larger shaded petals.

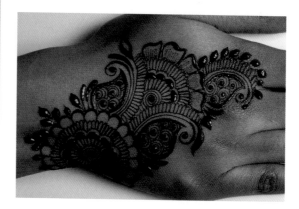

6. Draw another similar paisley above this flower.

7. Connect the paisley to the middle of the index finger by creating netting in the empty space.

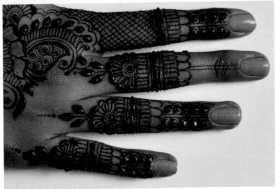

8. Fill the rest of the finger with thin petals followed by larger ones and a vine of filled leaves. On the other fingers, create a variation of thick and thin lines in the middle of each one.

9. Outline the lines on each finger with petals of different sizes. Then create a flower under the petals on the bottom of the finger with a set of three filled leaves and a vine of filled leaves at the top of the finger.

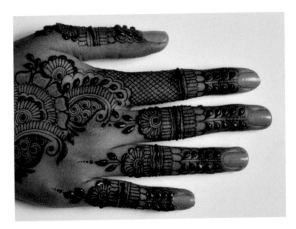

10. Repeat the same pattern on the rest of the fingers.

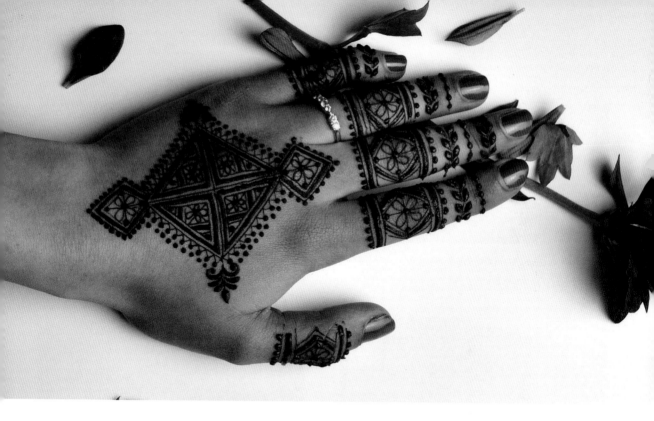

MOROCCAN-STYLE HENNA

Moroccan henna designs involve lots of straight lines, dots, and shapes like squares and triangles to create geometric patterns, in contrast to the round shapes seen in Indian and Arabic henna styles. This style is easy to apply, especially for beginners, due to its simple lines and shapes. The contemporary Moroccan henna patterns can be worn for any occasion to create a modern and trendy look.

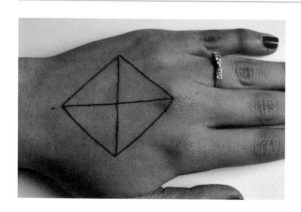

1. Start by drawing an X in the middle of your hand. Join the lines together to from a diamond shape with four triangles inside.

2. Line each triangle on the inside with a thicker line followed by a thinner line.

3. Fill in each triangle with a square and a small four-petal flower within that square. Outline the square with a thick and thin line.

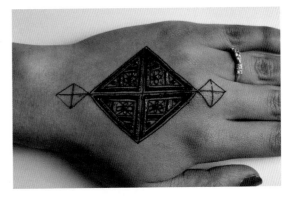

4. Now create two small diamond shapes, one at the top point of the diamond and one at the bottom.

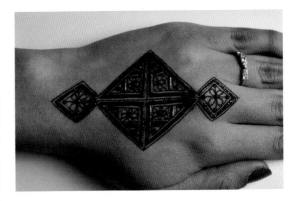

5. Fill the small diamond shapes with four-petal flowers and dots. Outline the entire shape with a thick and thin line.

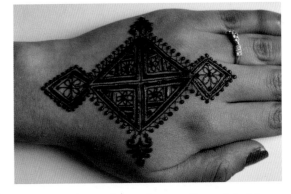

6. Draw small triangles on the outer lines of the bigger diamond with dots on each point of the triangles.

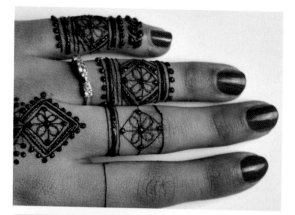

7. Moving on to the fingers, draw thin and thick lines on each finger, leaving an empty square space in the middle of each finger.

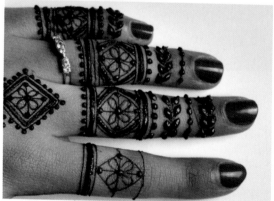

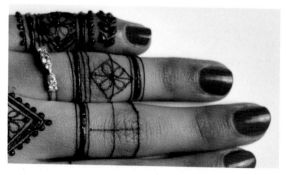

8. Draw diamond shapes inside the empty spaces on the fingers. The diamond shape should be split into four small triangles, which will then be used to create a four-petal flour within the diamond.

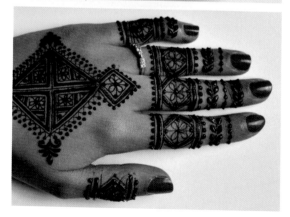

9. The rest of the finger space can be filled with dotted lines and leaves as shown, or it can be customized.

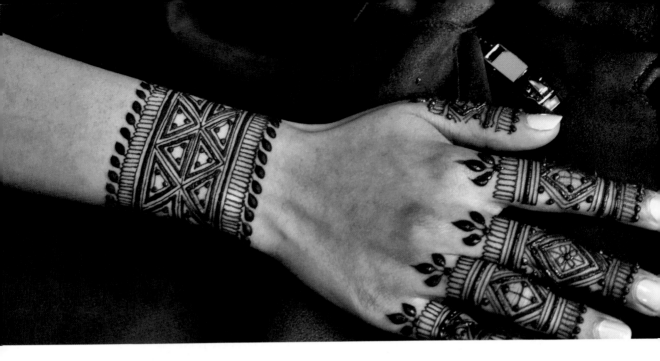

MOROCCAN-STYLE WRIST DESIGN

This design is easy to create using some simple line work, dots, and leaves. Most of the design is focused on the wrist and fingers for an elegant and modern look.

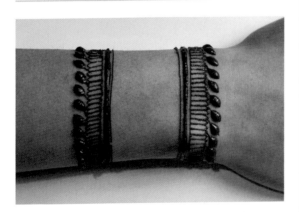

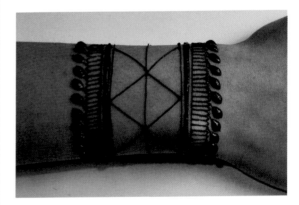

1. Start by creating two thin lines on the wrist, leaving a few inches of space in between them for the design work. Outline the lines with a thick line followed by a thin line. Make thin petals on the outer lines and add filled leaves.

2. Draw a line in the center of the empty space and within each half, draw lines to form small triangles.

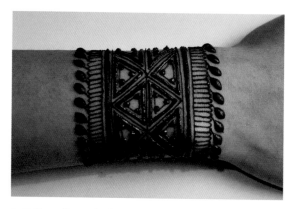

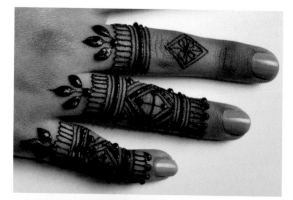

3. Follow along the lines of each triangle shape, varying between thick and thin lines to create smaller triangles within the larger ones. Then draw small three dots in each corner of the central smallest triangle.

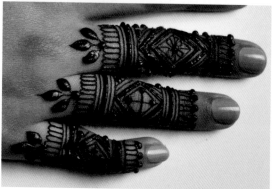

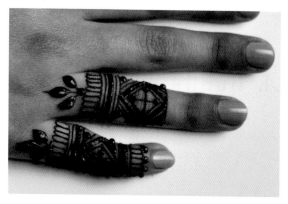

4. For the fingers, create two thin lines in the middle of the fingers, leaving an inch of space between them. Outline with thick and thin lines and petals. Draw a small diamond shape in the empty space between the lines, and fill with lines and dots.

5. You can add more lines on the middle finger to make it stand out more and also created a four-petal flower in the diamond shape.

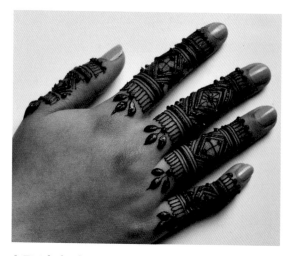

6. Finish the design with a set of three leaves at the bottom of each finger.

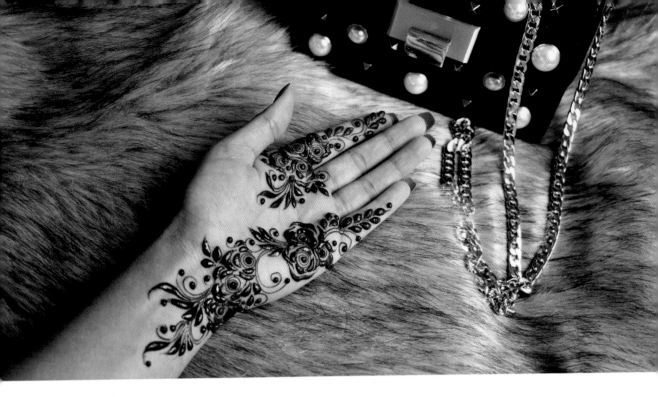

ARABIC-STYLE HENNA

Arabic-style henna consists of free-flowing patterns scattered on the hand, sometimes in a random order. Mostly made up of bold flowers, roses, vines of leaves, and dots, this style of henna is perfect for all occasions.

1. Create a rose on the bottom of the index finger, near the palm.

2. Draw a few more roses to create a bunch.

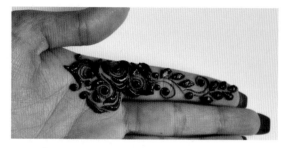

3. Next, draw some swirls and leaves on the rest of the index finger.

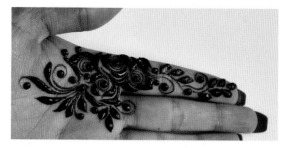

4. Draw larger leaves connected to the roses and extending onto the palm.

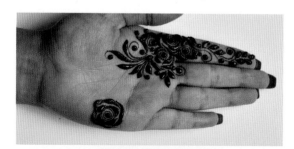

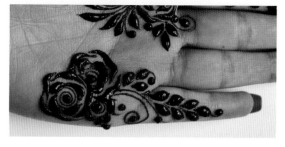

5. On the opposite edge of the hand, draw another rose and create a similar bunch of roses as in steps 1 and 2. Fill up the little finger with swirls and leaves.

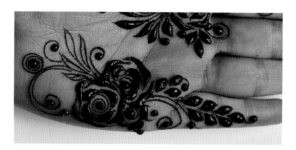

6. Draw a few more swirls on the other side of the roses extending to the wrist. An easy way to create the larger leaves is to draw an outline of them first and then fill it in.

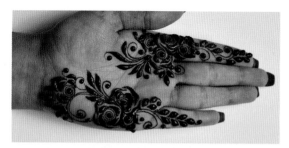

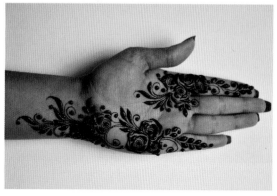

7. Continue the same pattern of roses and leaves down on to the wrist. You can extend the pattern as far down the arm as desired.

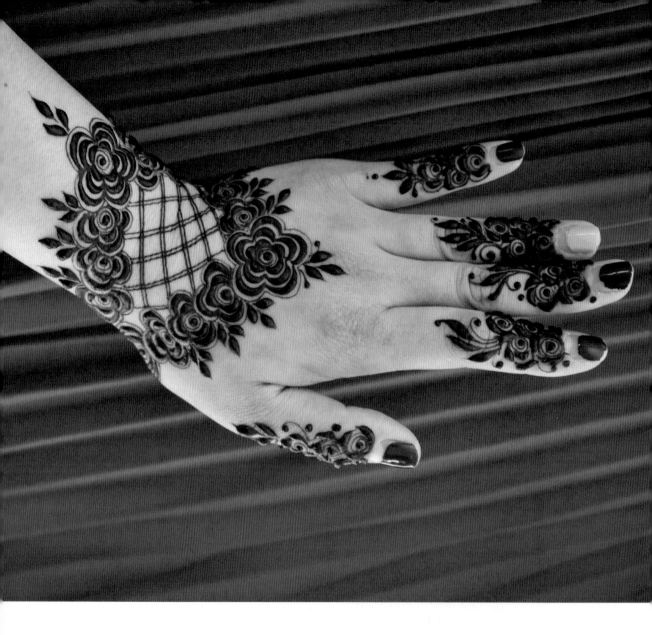

ARABIC FLOWERS AND NETTING

This beautiful design makes a bold statement with its Arabic-style flowers,
which are formed from repeating thick, round petals and roses.

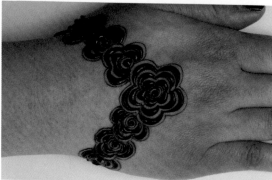

1. Draw a V of bold Arabic roses with thick petals with the point of the V facing the middle finger. A faint guideline will help you place the flowers evenly. Add a set of leaves between each flower.

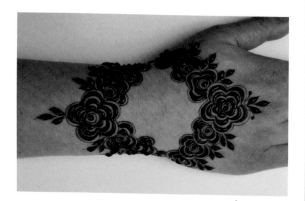

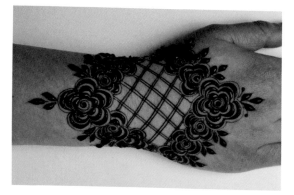

2. Next draw the same flowers in an opposite V shape, with the ends of the V reaching the sides of the wrist. You should be left with some space between the two lines of flowers. Fill the empty space with netting.

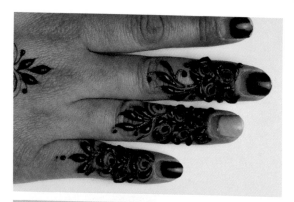

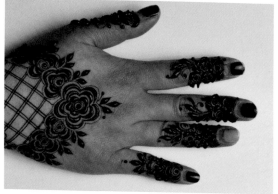

3. On the fingers, draw a set of four small Arabic roses, with a swirl in the center surrounded by four thick petals and leaves.

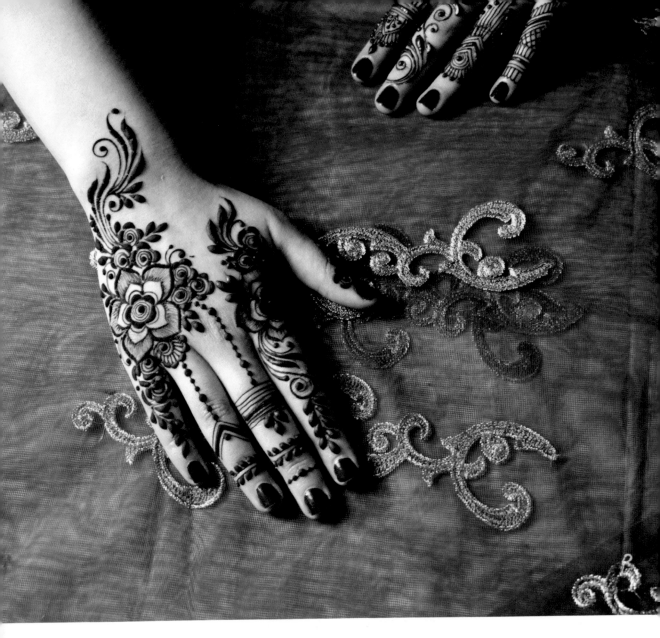

BOLD FLORALS

This elegant design featuring bold flower motifs is surrounded
by lots of leaves and Arabic-style roses.

1. Begin with a small rose near the outside of the hand and create layers around it to build it into a larger flower with bold, shaded petals.

2. Create a set of three roses under the flower motif followed by swirls and leaves.

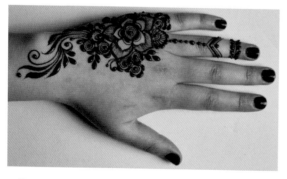

3. Draw some more roses around the flower motif. On the ring finger, create thick and thin lines in a V shape pointing toward the hand. Connect this to one of the roses on the hand with a dotted line. Draw a leafy vine on the top of the finger.

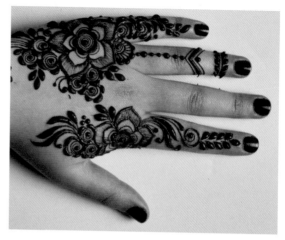

4. Create the same bold flower motif at the base of the index finger with roses and leaves under it. Draw a swirl flowing halfway onto the index finger, joined to the flower motif. Layer the swirl with leaves. Add some small roses and leaves to fill the space left on the little finger.

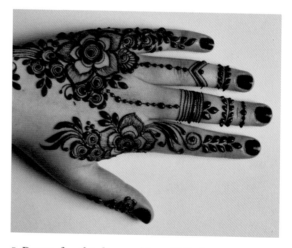

5. Draw a few thin lines on the middle finger and one thick line in between them. Connect this to one of the roses on the hand with a dotted line. At the top of the middle finger, draw a leafy vine and a horizontal dotted line. Complete the thumb with a few roses and some leaves.

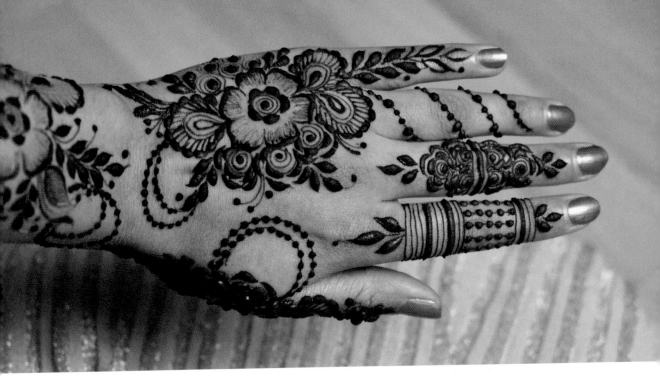

FLORALS AND LEAVES DESIGN

This beautiful design features a bunch of flowers and various elements strategically placed on the arm and hand to create an elegant look. Based on the Arabic-style of henna, one main flower is used as the focus point surrounded by small roses, leaves, and petals.

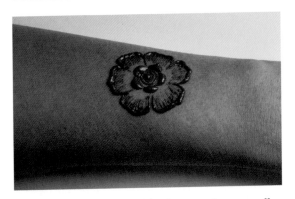 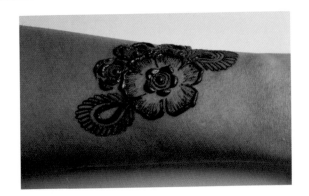

1. Starting in the middle of the forearm, draw a small rose with larger shaded petals around it to create a bigger flower.

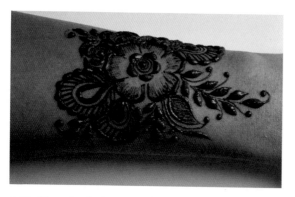

2. Build up the design around this flower by drawing some roses and leaves. The oval-shapes pictured here are a variation of the feather element that is typical of Arabic style henna. To create this, draw a small teardrop shape and outline it a few times until it is the desired size, and surround it with thin and thick petals as shown.

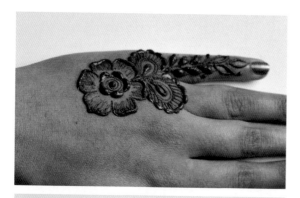

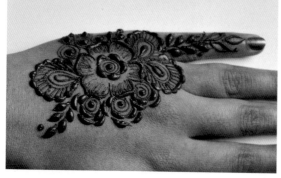

3. Repeat the same pattern on the hand with a vine of leaves extending on the little finger.

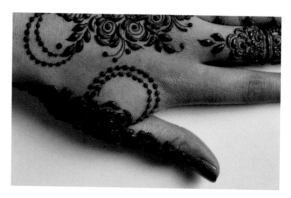

4. Create the same pattern below the thumb and extend it toward the top of the thumb. Draw dotted circles in a random order around the design.

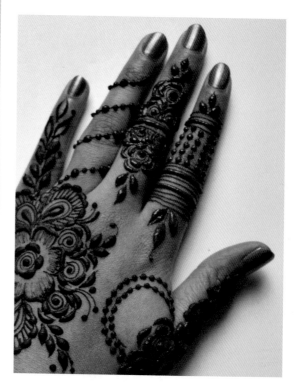

5. You can create different designs on each finger to make them unique. On the middle finger, draw a set of three roses. The index finger features thin lines with a few thick lines, as well as dotted lines. Finish the design on the fingers with leaves pointing down toward the hand.

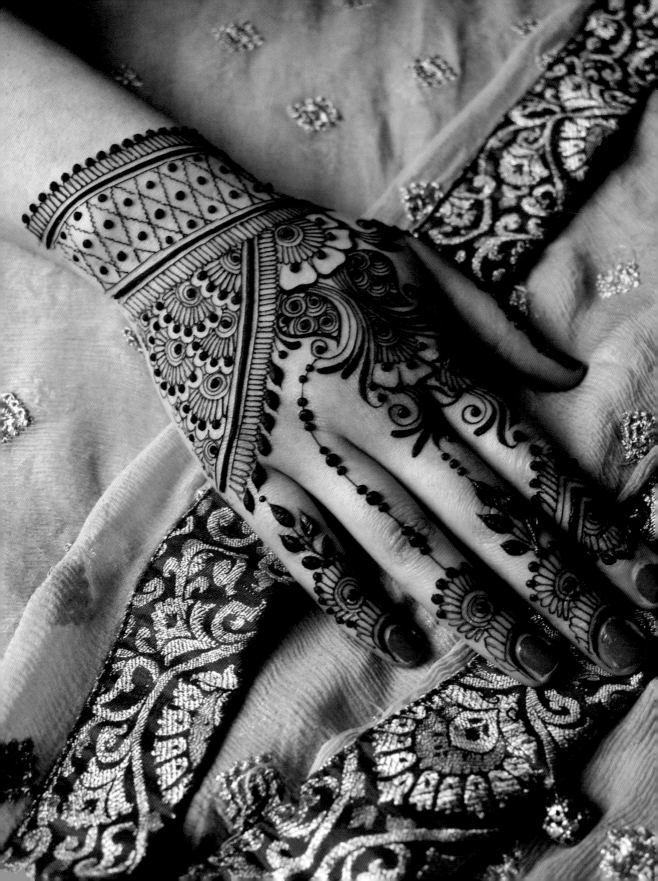

FLORALS AND FILLS

Structural fills and a flowy pattern of paisleys and flowers are the main features of this stylish design, which shows how different filler elements can be easily used in henna design layouts.

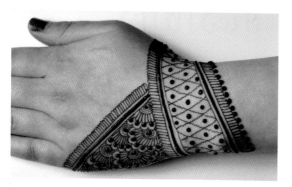

1. Start by creating a diagonal strip of empty space on the wrist. Join to this another diagonal section of empty space across the hand, meeting the side of the little finger. Outline the outer edges of the sections with varying lines and thin petals. The sections can be filled in using any preferred fills, such as netting patterns, florals, and negative space patterns. I have used a netting pattern in one section and a floral pattern in the other.

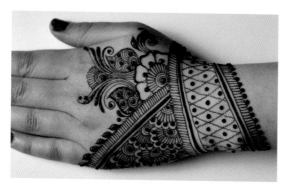

2. Draw a flower on the hand at the point where the different filled sections meet. Start to layer paisleys and swirls around the flower.

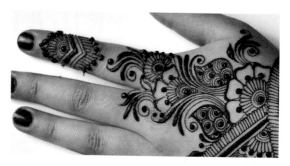

3. Continue building the paisley and swirl pattern until it reaches the middle of the index finger. Leave a little space and draw V shape on the index finger. Layer the shape with different lines and draw a simple flower at the top of the shape.

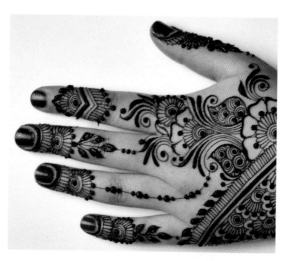

4. Outline the nails on the rest of the fingers and draw simple flowers below the nail of each finger, along with a set of leaves. On the ring finger, create a dotted line that connects to one of the paisleys on the hand to add a unique detail.

CHAPTER 6

COMPLEX AND HIGHLY INTRICATE DESIGNS

In this chapter, discover ten designs that fill up almost the entirety of the hands with highly detailed patterns.

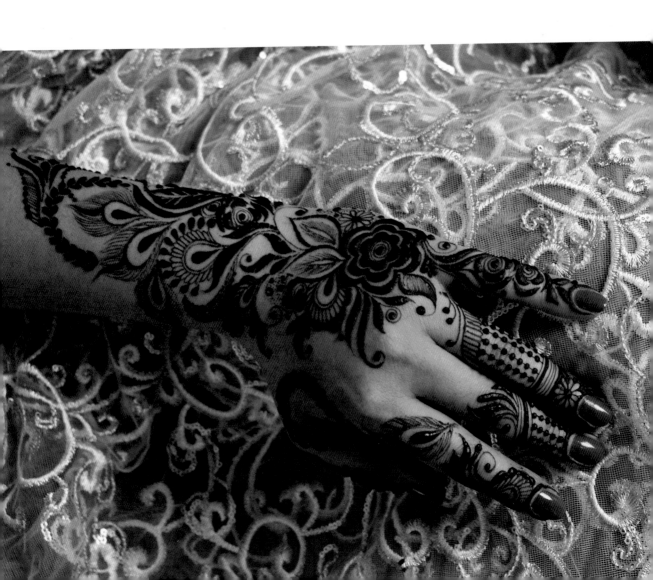

ARABIAN GULF-STYLE HENNA

This project is typical of the free-flowing Gulf-style henna seen in Middle Eastern countries. The bold floral patterns and fine details create an intricate and elegant look on the hand.

1. Start by drawing a bold flower at the side of the hand. This will be the base around which the rest of the design will flow.

2. Create leaves around the flower and small feather shapes with thin petals around them.

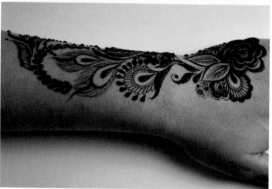

3. Continue using different Arabic elements such as leafy vines, feathers, roses, and swirls to continue the pattern toward the arm.

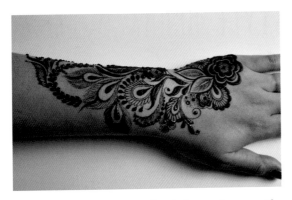

4. End the pattern at your preferred place on the arm with leaves or feathers, ensuring the elements are evenly placed throughout. If some areas look sparse, then fill these with small roses or leaves until you have the desired look.

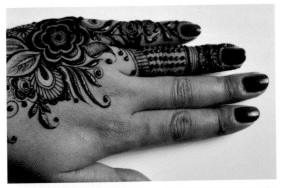

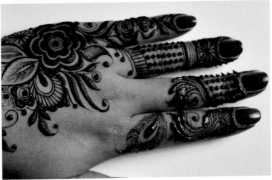

5. Now extend the pattern from the bold central flower up to the little finger. The best thing about Arabian Gulf-style henna is being able to create unique patterns on each finger that still help to bring the design together.

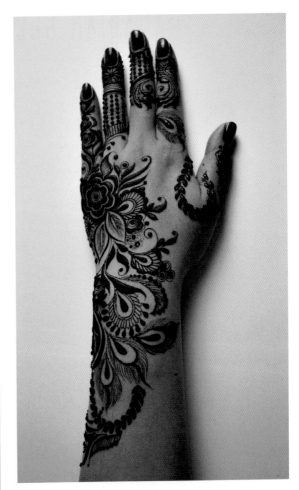

6. Finish the design with some roses on the thumb and a vine of leaves in the empty space near the thumb and index finger.

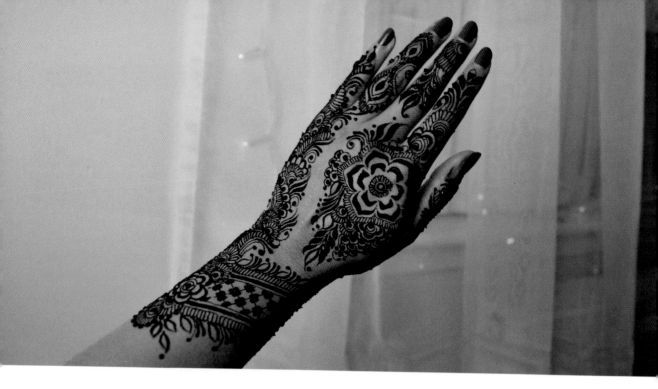

INTRICATE INDIAN DESIGN

Indian henna patterns like this one are very intricate with lots of small details covering most of the hand. This design is built up around a centerpiece, which is the bold flower. This trendy, covered-hand look is perfect for brides.

1. Make a small flower in the area where the index finger and thumb meet. Build the flower with a couple layers of bold petals around it.

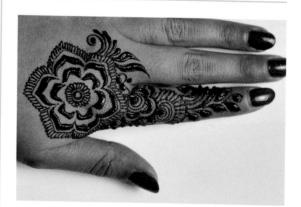

2. Now start creating smaller flowers, leaves, and other elements around this flower going up onto the index finger.

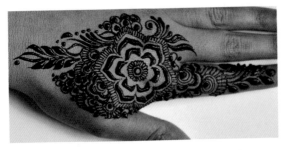

3. Continue adding different elements around the flower until you have one layer of details around it.

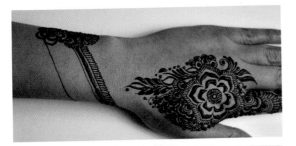

4. Leave an inch or so of space and move on to the wrist. Draw a bunch of flowers on one side of the wrist and a diagonal band of empty space. Fill in the band with netting and create leaves on the boundaries.

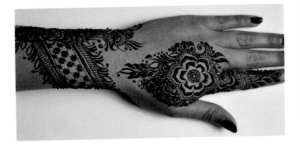

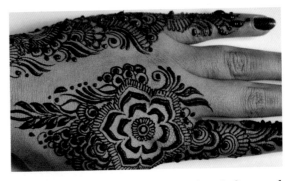

5. Start to create a repeated pattern of swirls, lines, and leaves extending from the wrist flowing onto the edge of the hand and up to the little finger. Ensure there is about an inch of space between the bold floral center piece and the rest of the design.

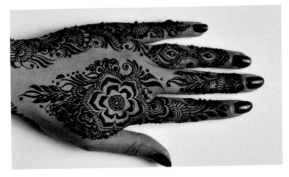

6. Now create different patterns on the rest of the fingers.

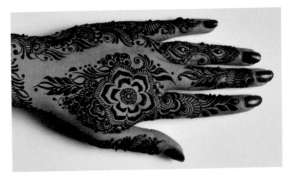

7. Create the same pattern as the little finger on the thumb and joined it onto the band at the wrist so that it incorporates well in the overall structure of the design.

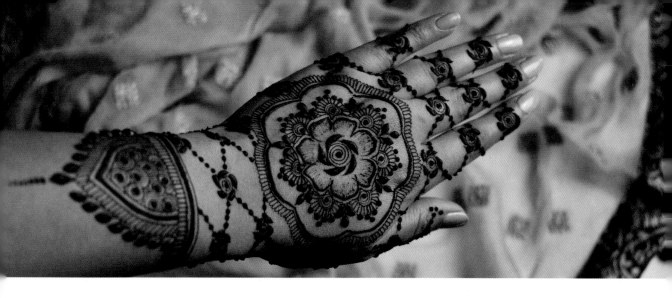

FILLED HAND DESIGN

This intricate design fills most of the hand with lots of florals and netting. It features the classic mandala connected to a net of roses and dots, with some details on the arm. It is a trendy, modern design that can be worn for any occasion.

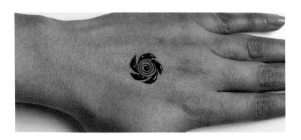

1. Start with a swirl in the center of the hand with petals to create a rose.

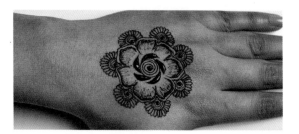

3. In between each large petal, draw a simple flower with thin petals.

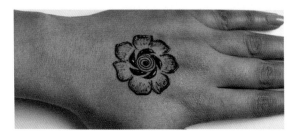

2. Create some larger shaded petals around the rose.

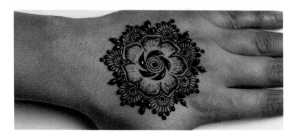

4. Fill the spaces between the small flowers with sets of three filled leaves and dots around the flower.

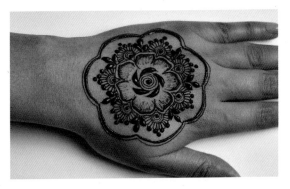

5. Draw an outline of thin and thick lines around the whole mandala shape.

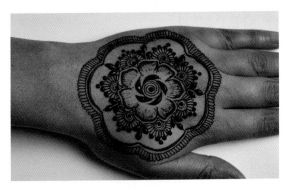

6. Create thin petals on the outer line.

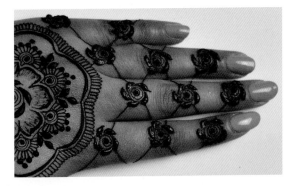

7. Create lines crossing each other to make a net-like design on all the fingers, connecting the lines to the mandala. At each point where the lines cross, draw a small rose. You can draw the lines more closely together to give a more detailed look.

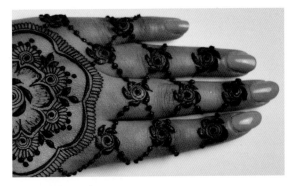

8. Put dots on the rest of lines.

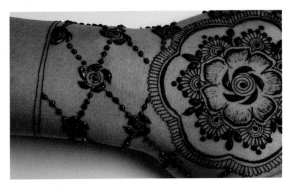

9. Create two thin lines an inch or two past the wrist. Create the same netting design with roses in the empty space between the mandala and lines.

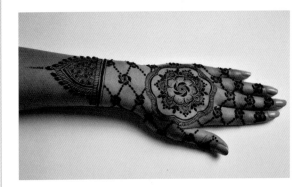

10. Draw thin petals on the outermost line on the wrist and a pointed dome shape connected to the line of petals. Fill the dome with swirls and dots. Create a thinner line with thin petals around the shape and filled leaves on the petals.

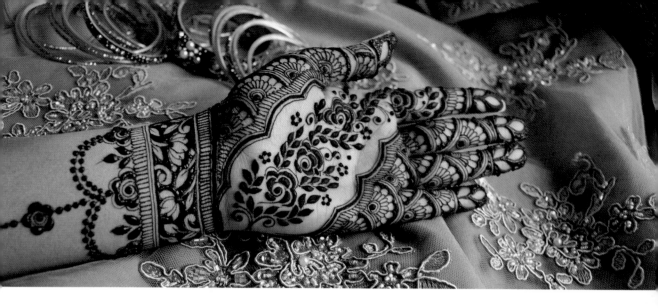

CLASSIC FULL-PALM DESIGN

In this design, a classic strip of henna runs diagonally from the wrist to index finger, surrounded by different fills. The design and fills can be changed as preferred while using the same layout. Ideal for special occasions and brides, this design gives a detailed look on the hand.

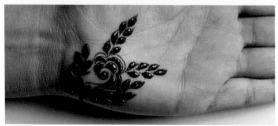

1. First create the strip in the middle. Starting from the edge of the palm, draw two vines of leaves with a rose in the middle.

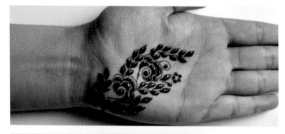

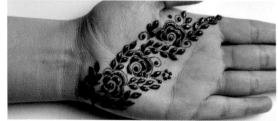

2. Continue the pattern of leafy vines with roses in the middle, stopping where the index finger begins. The strip can be changed with paisleys and various other flowers to create a unique look.

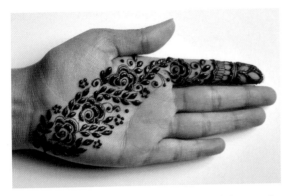

3. Complete the rest of the index finger with lines and petals. Draw a set of three leaves at the tip. To create a reverse fill, the leaves should remain empty and the space around them should be filled in with henna.

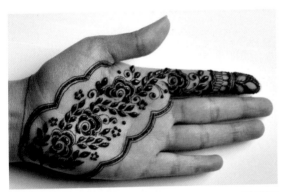

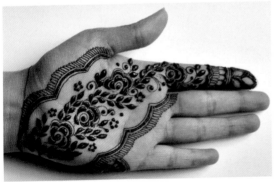

4. Next, draw a boundary line around the strip. This should be a variation of thick and thin lines, with thin petals on the outer line.

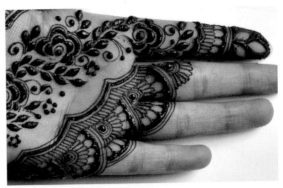

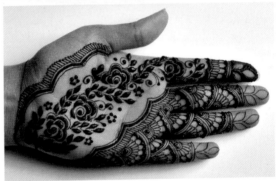

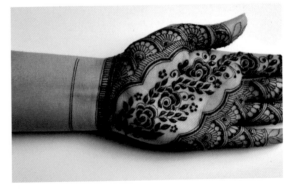

5. Now start filling in the rest of the empty space on the hand with flowers. Make sure to use the same type of flower for the entire filled area, leaving the tips of the fingers empty to create the three sets of leaves.

6. Once the whole hand is filled, move on to the wrist band. Draw a boundary line at the point where the hand and wrist meet and outline it with thick and thin lines and petals. Draw another line farther down the wrist to create a band of empty space.

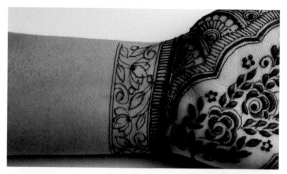

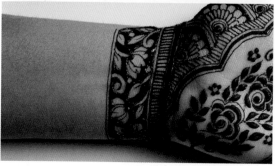

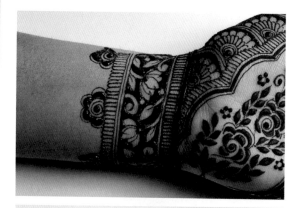

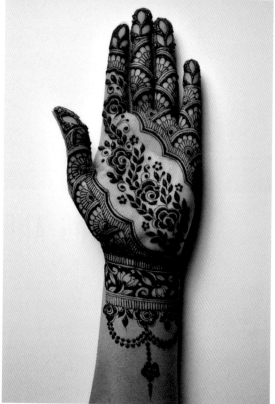

7. Fill in the empty band with a reverse fill. First create the pattern in the band then fill in the empty area around the pattern with henna, leaving the pattern empty.

8. Draw another line underneath the wrist band with some thin petals on it. Then draw three roses, one in the middle and two at the sides. Draw a set of three filled leaves in the each of the spaces between the roses. Connect the roses to each other with dotted line and finish off with a small rose coming down to the arm from the center of the dotted line.

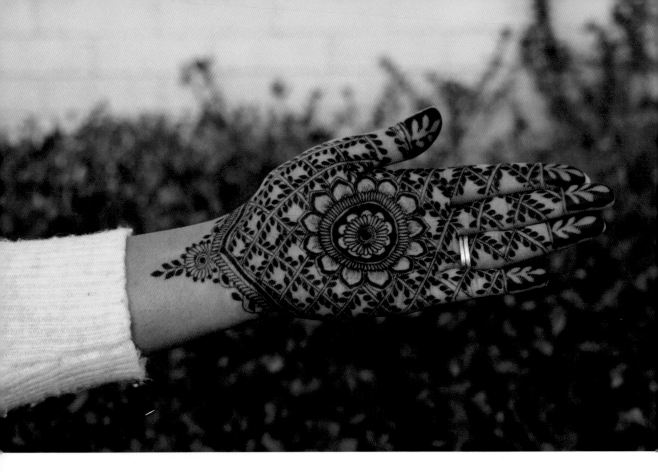

NETTING AND LEAVES DESIGN

This stunning, intricate design has a central flower and netting all over, surrounded
by small leaves with some negative-space leaves on the fingertips.

1. Make a simple flower in the center of the hand and
add thick round leaves around it.

2. Outline the round petals with a thick line followed by
a thin line. Make small, thin petals along the thin line.

 DIY HENNA TATTOOS

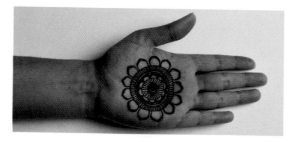

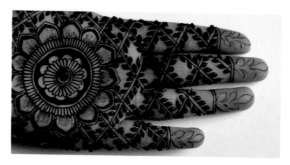

3. Draw large, round, pointed petals so that the whole flower fills the center and sides of the palm. Lightly shade the inside of the petals and add a thin outline around them. Then, draw a boundary line at your preferred area of the arm; here, the line is at the wrist. This line is drawn in a V shape here, but it can also be straight across. Also make boundary lines just under the fingertips, as those will done last.

6. Draw a thick outline along the leaves pattern, filling in the space around the pattern and fingertips to create negative space leaves.

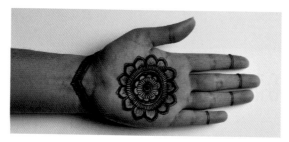

4. Now fill the rest of the space on the palm with double lines in a grid to create a netting effect. Ensure the lines are a fair distance apart so that the leaves can be drawn along the inside.

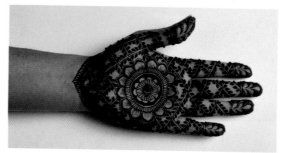

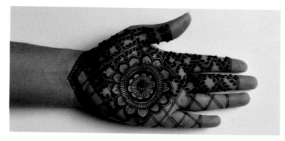

5. Make small filled leaves along the inside of all the squares created by the grid. Then, on each fingertip, make a faint outline of a set of leaves with two leaves on each side and one leaf at the top.

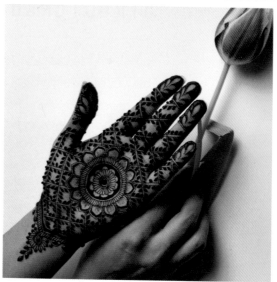

7. To complete the design, make a small flower at the point of the V shape line on the wrist and some filled leaves.

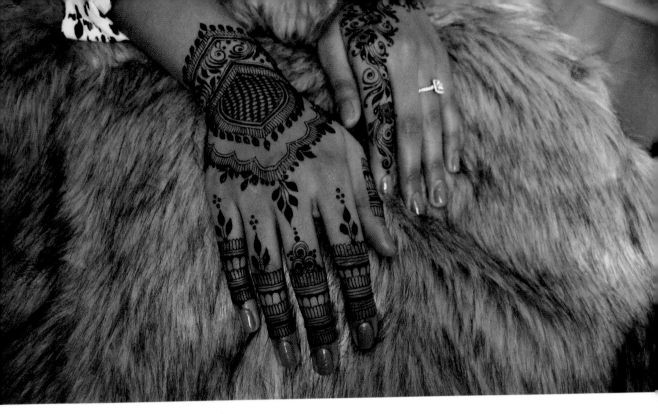

STRUCTURED FLORAL DESIGN

This structured design covers most of the hand and wrist with intricate details and fills, which is very trendy and in style.

1. Draw two V-shaped lines just below the wrist pointing away from the hand, leaving an inch or two of empty space between them. On the line closer to the arm, draw a line of petals and filled leaves.

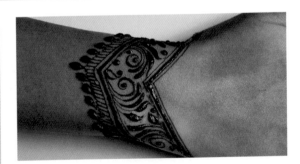

2. Fill the empty area between the lines with swirls and leafy lines.

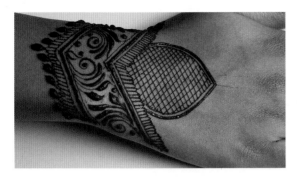

3. Create a line of petals on the inner line and a pointed dome shape on top of V-shape line, facing the fingers. Extend the dome onto half of the hand and fill it with a grid of crossed lines.

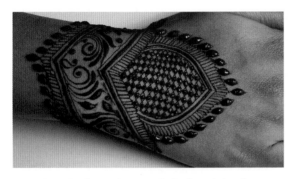

4. Outline the dome shape with thick and thin lines and a line of petals. Draw filled leaves on the line of petals, as was done on the arm.

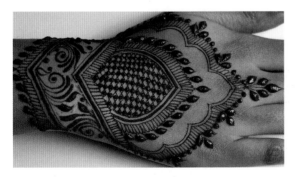

5. Leave some space and draw a scalloped V-shape line. Outline this with a line of thin petals and a set of three filled leaves at each point in the line. The leaves on the middle finger should be larger. Draw dots on the area where there are no leaves.

6. On the fingers, draw a variety of lines, including lines with thin and larger petals. Repeat this pattern until each finger is filled and finish of each finger with a set of three filled leaves at the bottom.

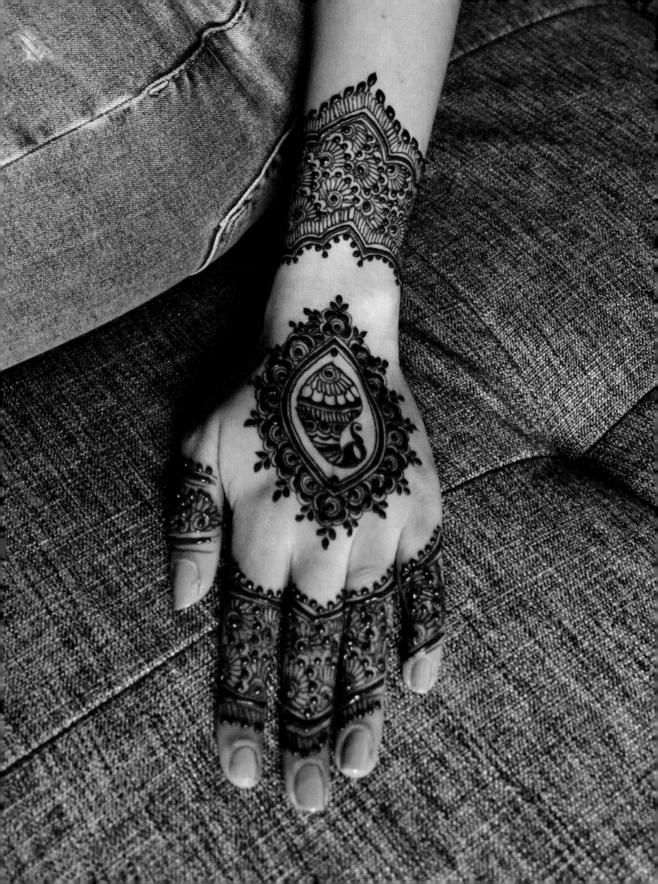

PEACOCK MOTIF AND FILLS

Another exquisite design, this henna showcases a delicate peacock motif in the form of a central paisley surrounded with floral fills.

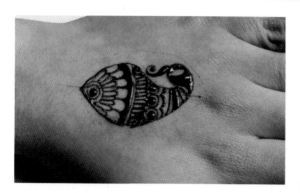

1. Draw a paisley in the center of the hand with a round head at the top of it rather than the usual pointy end. This will be the head of the peacock. Fill the paisley with different elements like flowers and line work. Fill in the round head with henna, leaving a small space to highlight the eye of the peacock, and also draw a very small paisley with a swirl joined to the head. Drawing a faint guideline on the center of the hand helps to keep everything symmetrical.

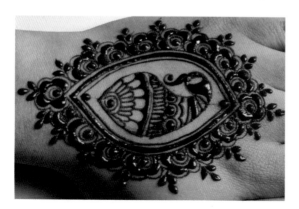

2. Make two rounded lines meet at the top and bottom of the paisley. Draw a thicker line around this line followed by a thin line. Create small roses all around

the outer line, and also outline the roses with thin lines. Add a set of small three leaves in between each of the roses.

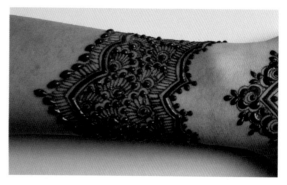

3. Leave some space below the wrist and make two parallel lines with scalloped curvy edges, leaving a couple of inches of space between them. Fill this empty space with a floral fill, using small flowers with dots connecting them in an intricate pattern. Finish the outer edges of the scalloped line with a line of thin petals and leaves.

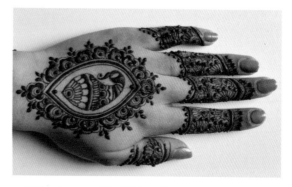

4. Make the same floral fill in the same shape on the fingers at the top of the hand.

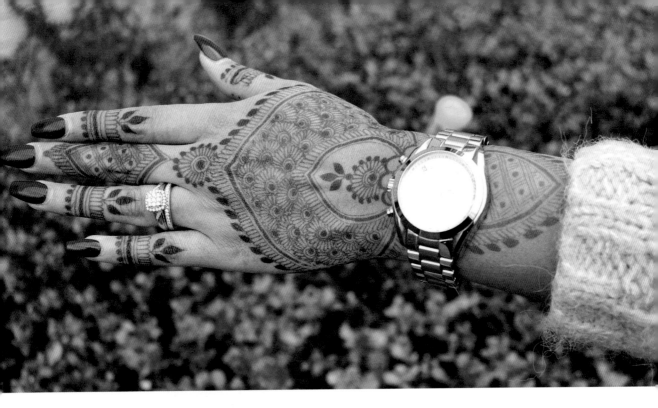

STRUCTURED HENNA DESIGN

This beautiful design is formed using a structured layout with different fills. It fills up most of the hand with oval domed shapes and various flowers, creating a detailed, trendy look on the hand. This design is perfect for all occasions, especially weddings.

1. Start by drawing a flower on the middle of the wrist, layering it with large petals. This flower is the base to which the rest of the shapes are connected.

2. On top of the flower, draw a dome shape with a point. Outline this with varying lines and petals. Draw a simple flower inside it with a set of leaves on top.

3. Below the flower, draw a dome shape slightly larger than the previous one, layering it with lines and petals. Fill this dome shape with netting and dots.

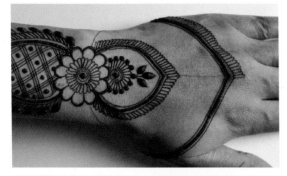

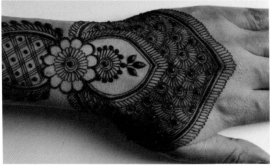

4. Now draw a faint line from the dome shape on top of the flower toward the middle finger. This line will act as a guide to create an even shape on both sides of the hand. Leaving about an inch of empty space, draw a soft V following the dome shape. Outline this with varying lines and petals. Fill the empty space between the shapes with simple flowers.

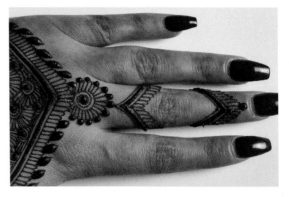

5. Create a flower on the point of the V shape, flowing onto the base of the middle finger. Draw a trail of leaves on the edge of the shape. Using the same method, draw V shapes on top and bottom of the middle finger, leaving an empty space between them.

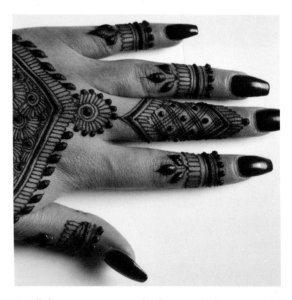

6. Fill the empty space on the finger with the same grid pattern as in the dome shape on the arm to complement the rest of the design. The rest of the fingers are kept simple, with varying lines, petals, and leaves.

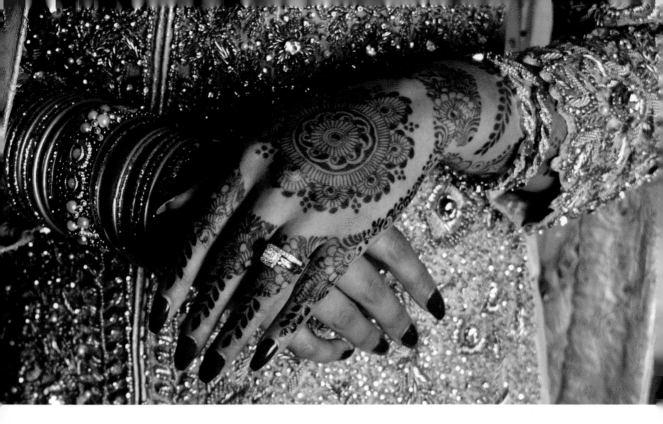

BRIDAL HENNA DESIGN

Bridal henna designs are made up of various elements, patterns, and structures based on personal preferences. Unlike any other design, bridal henna depicts a greater amount of detail and intricacy, covering all of the hands and arms. With time and practice, it is easy to master the art of bridal henna. This design shows how one can be built around a classic mandala, which is typical for most bridal designs. This design is perfect for all occasions, especially weddings.

1. First create the mandala. Start by drawing a simple flower in the center of the hand, adding small paisleys on the outer edge.

2. Add different layers to the flower, like thick and thin lines and petals, as shown.

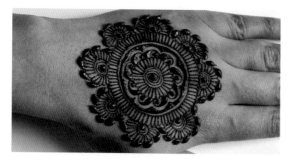

3. Now draw a layer of simple flowers around the outer edge to complete the mandala. Draw thicker strokes of petals on the flowers by applying pressure on henna cone and releasing.

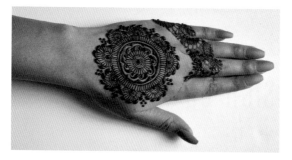

4. Leave half an inch of space above the mandala and draw two faint guidelines with your desired amount of space between them. This space will be filled be with continuous henna pattern, including swirls, leaves, and flowers. Ensure the pattern stays within the guidelines created.

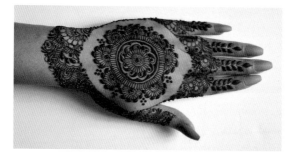

5. Continue the pattern all the way around the entire mandala. Draw a vine of filled leaves on the space left on each finger. This is done in the same way by

applying pressure on the cone and releasing. The pattern around the mandala should finish just under the wrist.

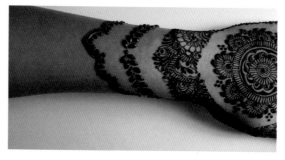

6. Continue to build the design on the arm by adding on layers. Leave some space in between each layer. Here is a layer of leaves and then a scalloped layer of thick and thin lines with dots.

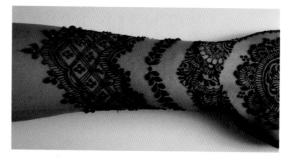

7. Draw another scalloped edge a couple of inches lower than the one before, outlining with dots and variation of lines. Now fill the space between the two edges with lines crossing each other to create a grid pattern. Within each square of the grid, draw four dots. Finish the outer edge with a boundary of thin petals and a set of three leaves in each corner of the scalloped edge. This design can be extended farther up the arm as desired by building on more layers or floral elements.

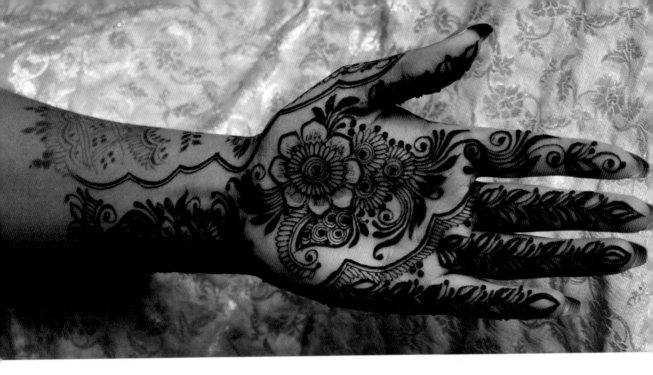

BRIDAL HENNA DESIGN ON PALM

This design is a continuation of the bridal henna design created on the outer part of the hand (page 116). Here you will see how to connect the patterns to each other. This design is not restricted to brides only, and can be worn for any occasion.

1. Some of the bridal design from the other side of the arm can be seen on the inside of the arm. I have created a scalloped boundary around the design so there is a clear distinction between the two patterns. You can also continue the same pattern on the inside of the hand and arm if desired.

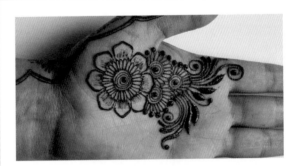

2. Draw a large flower on the side of the palm with small and large petals. This will be the focus point around which the rest of the pattern will be formed. Draw another set of flowers next to the larger flower, and also swirls with leaves.

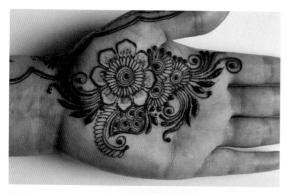

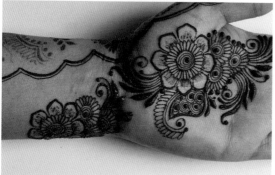

3. Continue drawing different elements around the flower, like a paisley and more swirls with leaves, until half of the palm is filled. Draw the same pattern on the arm.

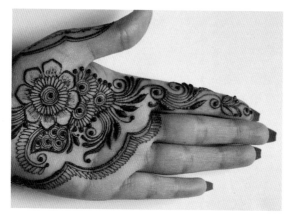

4. Extend the swirly pattern onto the index finger. Create a boundary around the design from the bottom of the index finger to the farthest edge of the arm. Layer this line with thin petals.

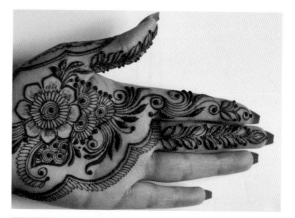

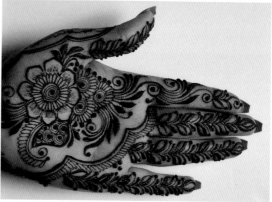

5. On the rest of the fingers, create a vine of unfilled large leaves, with smaller leaves between them.

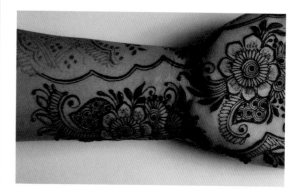

6. Finish the pattern on the arm with a paisley and some unfilled leaves.

HENNA-PATTERNED PHONE CASES

Henna designs don't have to be just for the skin! In this chapter, you'll learn how to use acrylic paints to create gorgeous henna-inspired phone cases.

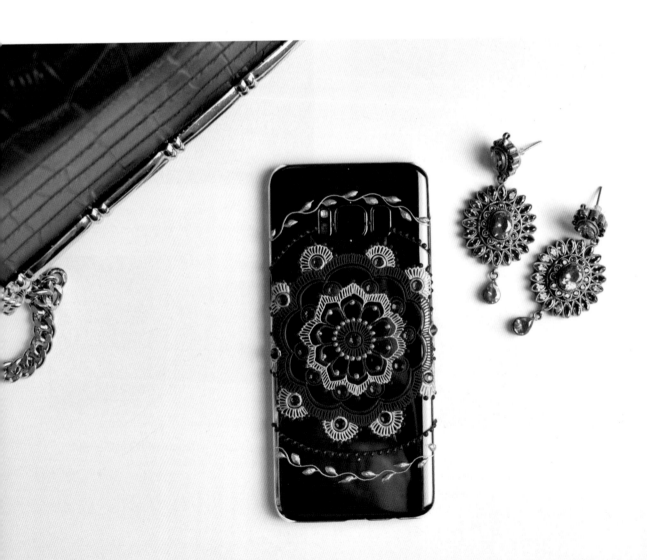

HENNA ART USING ACRYLIC PAINTS

Henna art is not limited to the hands or other parts of the body. You can also create henna patterns on different items using acrylic paints. The possibilities are endless. It is very simple to make your own acrylic paint cones at home to decorate items. It is essential to use good-quality paints for best results.

Supplies

- Empty cellophane cones
- Good-quality acrylic paints
- Scotch tape
- Scissors

1. Fill the empty cones with the desired colors of acrylic paint.

2. Seal the ends of the cones with tape. Your acrylic paints cones are ready to be used to decorate many items, including candles, phone cases, vases, canvases, etc. When ready to use, use the scissors to cut the tip of the cone to the desired width.

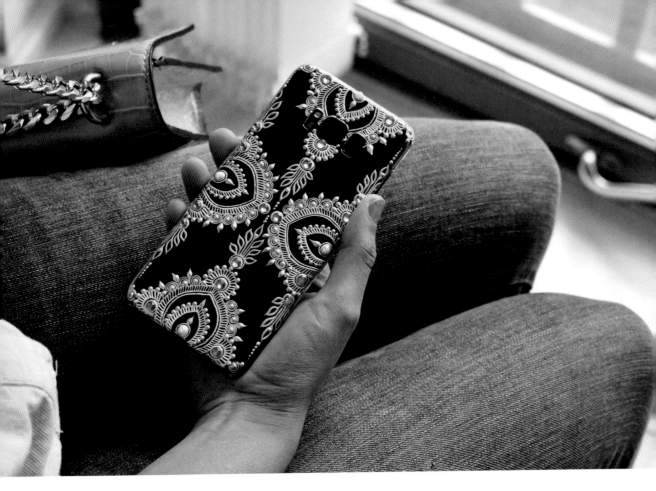

SILVER AND TURQUOISE PHONE CASE

A phone case with henna patterns looks exceptionally beautiful when in use. This simple project makes the perfect gift for loved ones. Let the case dry for at least 24 hours before using.

Supplies

- 1 cone filled with silver acrylic paint

- 1 cone filled with turquoise acrylic paint

- Pearls and pink rhinestones

- All-purpose glue

- Pointed tool for applying glue

- Clear plastic hard-back phone case

1. Measure and mark the center point of the phone case using a ruler. Glue a pearl onto the center point at the top and bottom of the phone case. Outline the pearls using the silver paint cone. Leave some space and draw pointed dome shapes around the pearls. Layer the shapes with thin petals. Leave some more space and draw another domed shape around the smaller domes,, repeating the same thin petals on the edge.

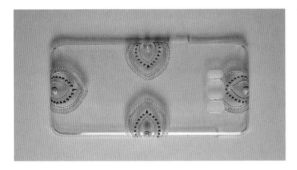

2. Mark the centers on the sides of the phone case and repeat the same domed pattern on the sides. Using the turquoise paint, draw dots on the edges of the petals.

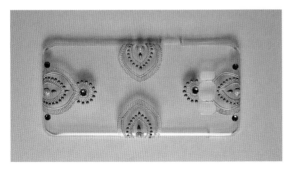

3. Place a light pink rhinestone at the top of each dome at the ends of the case, and draw a simple flower around it. Place two more rhinestones on each side of these domes and draw the same flower.

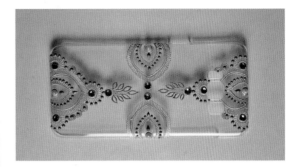

4. Make dots around the flowers with turquoise paint. Place another pink rhinestone on the top of each flower and draw a set of leaves extending from the stone using turquoise paint.

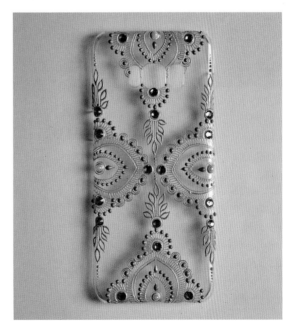

5. Create swirls with turquoise paint on the rest of the space around the domes. Create leaves extending from the rhinestones on the sides of the phone case.

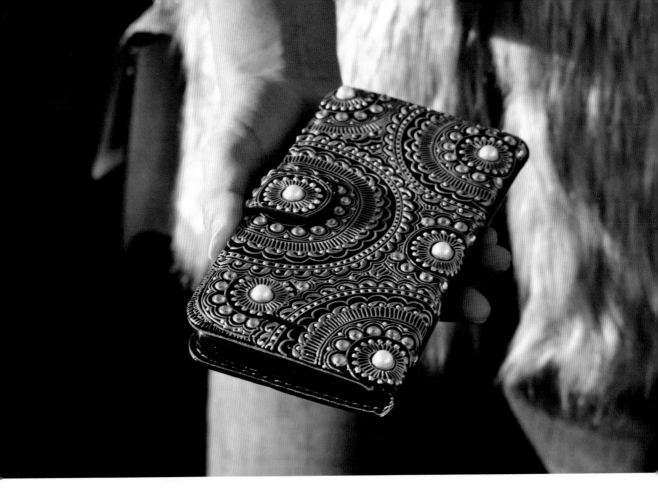

GOLDEN MANDALAS PHONE CASE

This black flip cover decorated with intricate mandala patterns in gold and silver case looks spectacular and provides full protection. Let the case dry for at least 24 hours before using.

Supplies

- 1 cone filled with gold acrylic paint
- 1 cone filled with silver acrylic paint
- Pearls and silver rhinestones
- All-purpose glue
- Pointed tool for applying glue
- Black leather flip cover or wallet

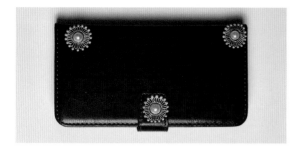

1. Glue 3 pearls on the phone case: one at the top left corner, one at the bottom left corner, and one in the middle of the right side, where the magnetic flap is. Create simple flowers around each pearl with the gold paint. Surround the flowers with dots using silver paint.

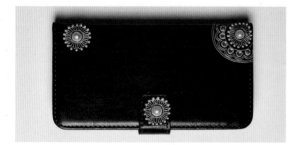

2. Draw a line around one flower and glue on silver rhinestones, leaving an even space between them. Outline the rhinestones with gold paint. Make a line around the rhinestones.

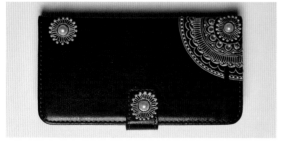

3. Draw thin petals on the line followed by small swirls in the shape of paisleys. Leave some space and outline the paisley swirls. Create two thin lines around the entire mandala. Use the silver paint to create dots within the two lines. Draw a final line around the mandala.

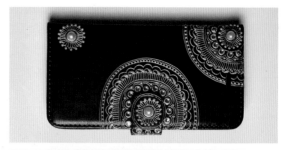

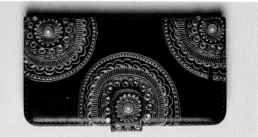

4. Repeat the same pattern on the other two flowers to form the same mandalas.

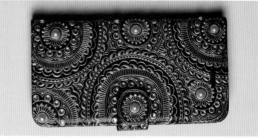

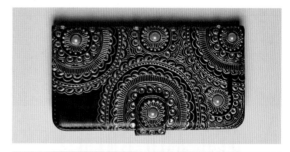

5. Make another round of paisley swirls on the outer line of each mandala and outline them. Fill in the remaining space on the phone case by drawing the same mandala patterns until no empty space is left.

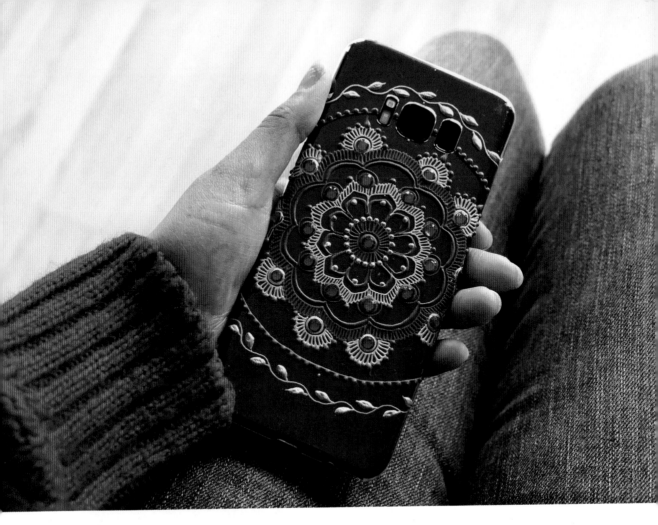

RED AND GOLD HENNA DESIGN PHONE CASE

This case features an expanding mandala in red and gold. Let
the case dry for at least 24 hours before using.

Supplies

- 1 cone filled with red acrylic paint

- 1 cone filled with gold acrylic paint

- Red rhinestones

- All-purpose glue

- Pointed tool for applying glue

- Clear plastic hardback phone cover

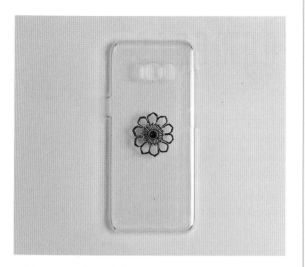

1. Measure and mark the center point of the phone cover using a ruler. Glue a red rhinestone at the center and outline it with the red paint. Draw a flower in red surrounded by golden dots. Make larger petals around the flower in red paint.

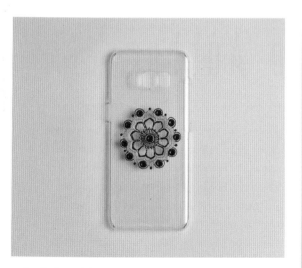

2. With the gold paint, outline the flower and draw thin petals around it. Within each petal, add a red rhinestone. Outline the rhinestones using red paint.

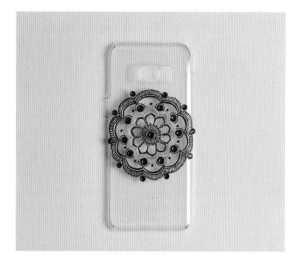

3. Join the rhinestones together by drawing a line from one to the other in red. Make another line around it and add thin petals. The floral mandala will be spread out enough to fill the sides of the phone case at this point. Add another layer of red rhinestones within the points on the petal line.

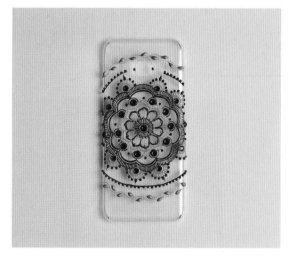

4. Draw small flowers around the red rhinestones using gold paint. Surround the flowers with dots in red paint. Draw a dotted line around the mandala also in red. Finally, use the gold paint to draw a wavy line around the perimeter of the mandala and add a filled leaf within each curve of the wavy line.

Acknowledgments

I am grateful to have such a great support network of people who have been with me throughout this book journey. I wish to thank the following people for helping me to make this book a reality:

My husband, Usman, for believing in me and for his patience while most of my time was consumed with doing henna on myself and others for the book. He was always there to assist me with taking photos whenever I needed him to, and for that I am forever thankful.

My family and friends for lending me their hands for henna and supporting my designs. Without you this book would not be possible.

Claire and the entire Ulysses Press team for giving me this incredible opportunity to show my passion for henna art and supporting me throughout this whole project and any issues I encountered.

The online henna community for endlessly inspiring me with their immense talents and to create unique designs which I feel proud to share with the world.

About the Author

Aroosa Shahid is a passionate henna artist who is also engaged in the social services and care industry. Her journey into the art of henna began at the age of 14 while doodling on herself and family members. She loves to draw designs, take on DIY projects, and travel. Aroosa holds a bachelor's degree in psychology and human health from Heriot Watt University. She finds henna art to be incredibly therapeutic and calming. She lives with her husband in the UK. Inspiring henna designs from Aroosa can be found on Instagram @aroosa_shahid, and in video tutorials on youtube.com/Hennaartbyaroosa.